ACQUISITION PRIORITIES: ASPECTS OF POSTWAR PAINTING IN AMERICA

ACQUISITION PRIORITIES

ASPECTS OF POSTWAR PAINTING IN AMERICA

Including **Arshile Gorky: Works 1944-1948**

This project is supported by a grant from the National Endowment
for the Arts in Washington, D.C., a Federal Agency

The Solomon R. Guggenheim Museum, New York

Published by The Solomon R. Guggenheim Foundation, New York, 1976
ISBN 0-89207-005-6
Library of Congress Card Catalogue Number 76-29096
© The Solomon R. Guggenheim Foundation, 1976
Printed in the United States

Table of Contents

Lenders to the Exhibition

Arshile Gorky: Works 1944-1948

Joseph H. Hirshhorn

Mrs. H. Gates Lloyd

Mr. and Mrs. Howard Wise, New York

The Art Institute of Chicago

Allan Stone and Harold Diamond

Acquisition Priorities: Aspects of Postwar Painting in America

Harry N. Abrams Family Collection, New York

Mr. and Mrs. John Murray Cuddihy

Phyllis Diebenkorn

Edward F. Dragon

Joanne du Pont, New York

Susan Morse Hilles

Jasper Johns

Fred Mueller, New York

Mr. and Mrs. S. I. Newhouse, Jr.

Annalee Newman

Estate of Mark Rothko, courtesy of Marlborough Gallery, Inc.

Mr. and Mrs. Sidney Singer, New York

The Solomon R. Guggenheim Museum, New York

Acquavella Contemporary Art, Inc., New York

Blum/Helman Gallery, New York

Leo Castelli Gallery, New York

Xavier Fourcade, Inc., New York

Nancy Hoffman Gallery, New York

M. Knoedler & Co., Inc., New York

Marlborough Gallery, New York

The Pace Gallery, New York

Betty Parsons Gallery, New York

Willard Gallery

Acknowledgements

This exhibition of modern American painting necessarily concerns many individuals who make up the creative art world in this country today. More than one half of the thirty-two artists represented here are alive, and almost all of these became involved in one way or another in the Guggenheim's preparations for the show. It is therefore to the artists themselves or to those who represent their legacy—executors, dealers or members of their families—that we are primarily indebted.

The location of particular paintings and the related research necessary for the successful organization of this exhibition often required more than ordinary exertions and could not have been accomplished at all without the aid of Lawrence Alloway, Linda Cathcart, Jim Jordan, Clifford Ross, Edward Ross, William Scharf, Ethel Schwabacher, Maureen St. Onge and Jock Truman, among others.

The names of lenders, limited for the purpose of this exhibition to private collectors and dealers, are listed separately. Their contributions in every instance add significantly to the quality of the show and in some cases may come to enhance the richness of the Guggenheim Collection.

As always, energetic and informed efforts by staff on all levels are required to realize an exhibition and a catalogue of this scale and scope. In this instance, staff members most centrally concerned with these tasks besides Linda Shearer, the Guggenheim's Assistant Curator, include Diane Waldman, Curator of Exhibitions, Carol Fuerstein, Editor, Linda Konheim, Curatorial Administrator, and Susan Ferleger, Curatorial Assistant.

For their invaluable help and for the friendship implied by their services, I would like to express my sincerest thanks to all those listed above in the name of Mrs. Shearer and of the Guggenheim Museum.

THOMAS M. MESSER, DIRECTOR
The Solomon R. Guggenheim Museum

Foreword

This exhibition is primarily a balance sheet—a frank admission of what, within a particular context, we value most and, conversely, what we at present most sorely lack. The selection consists of works from the Museum's permanent collection, shown alongside others that are not part of its present holdings, but are high on our list of acquisition priorities. The juxtaposition of assets and liabilities thus takes the form of an institutional self-critique, a public projection of our weakness rather than our strength. At the same time the exercise is meant to be remedial, for the borrowed works on view can, and to some extent perhaps will, be acquired either now or in the future. With the possibility of such acquisitions in mind, all loans except the paintings of Arshile Gorky were drawn from private collections or from commercial galleries. Works from the former source are at least theoretically potential donations; those from the latter source, potential purchases. However, while some paintings in the show are at present subjects of negotiation between their owners and the Guggenheim, others are included merely for their exemplary attributes and without expectation of acquisition in the foreseeable future.

The presentation is not meant as a general survey of the period covered. Only incidentally and insofar as it expresses the Guggenheim's acquisition priorities does the exhibition provide a review of certain aspects of postwar painting in America. The selection spans the postwar years and covers a wide range in terms of generations. The oldest artist included was born in 1880, the youngest in 1936.

The acquisition priorities reflected in this exhibition are our own, and we raise no claims for their validity beyond this Museum's needs as we assess them. I made the selection from the Guggenheim's collection and chose those works not now in our holdings with the help and the concurrence of the Museum's curators especially close to the subject, in particular Diane Waldman, Curator of Exhibitions. Linda Shearer, the Guggenheim's Assistant Curator, has taken an active part by leading the search for loans that might eventually become part of the collection.

Acquisition priorities of course remain a constant for any museum actively engaged in collecting. To the extent to which existing priorities are fulfilled by acquisition, new ones will arise. Through such a process, our present narrow format may broaden into a less restrictive, richer and more comprehensive exhibition statement. The gradual and still continuing development of the Guggenheim's prewar collection—the result of a nearly 40 year effort—will, we trust, point the way.

T. M. M.

Index to the Checklist

Works in the exhibition

The listing for the *Gorky* presentation is arranged chronologically, with paintings of the same year listed alphabetically. The checklist for *Acquisition Priorities* is arranged chronologically by artists' birthdates. In the latter checklist artists born in the same year are listed alphabetically and paintings are listed chronologically under each artist. Height precedes width. The acquisition number of each piece follows The Solomon R. Guggenheim Museum Collection credit line: the first two digits of this number indicate the year in which the work was acquired.
* Indicates the painting is reproduced in color as well as in black and white.

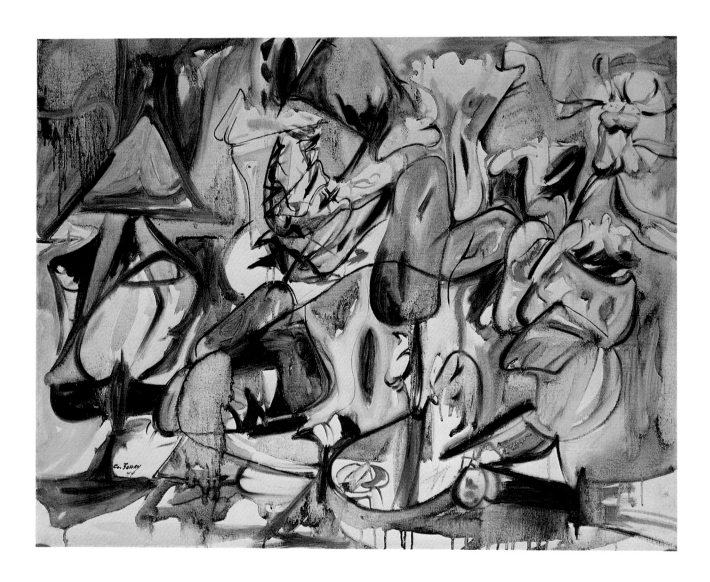

GORKY

1 *The Leaf of the Artichoke Is an Owl.* 1944
Lent by Allan Stone and Harold Diamond

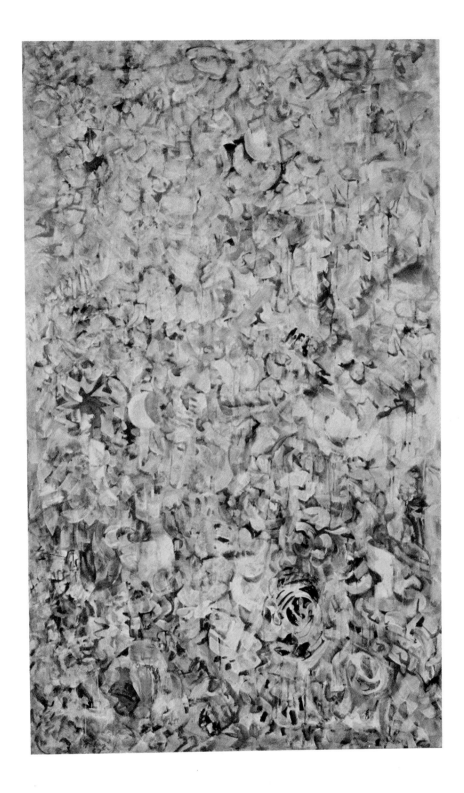

TOBEY

9 *Appearances in Time.* 1962
 Lent by Willard Gallery

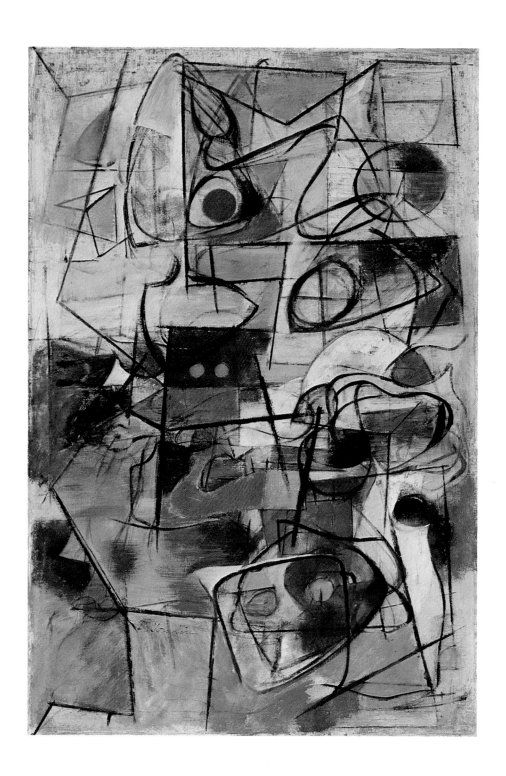

TOMLIN

12 *No. 10-A.* 1949
Private Collection, New York

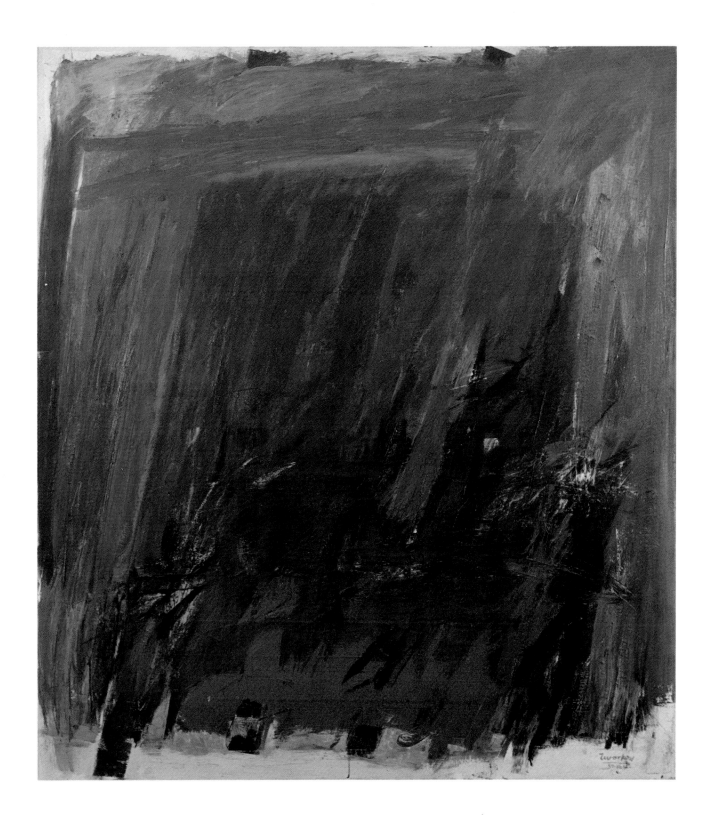

TWORKOV

13 *Red Lode.* 1959-60
Lent by Nancy Hoffman Gallery, New York

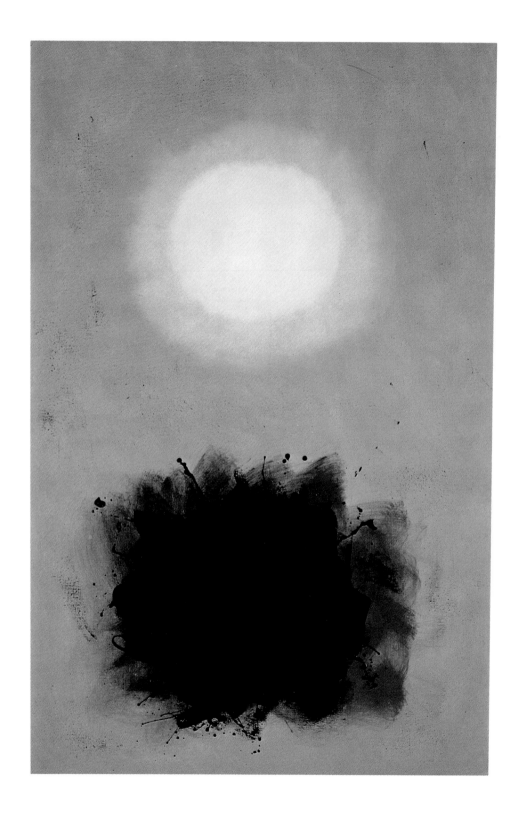

GOTTLIEB

17 *Mist.* 1961
Collection Susan Morse Hilles

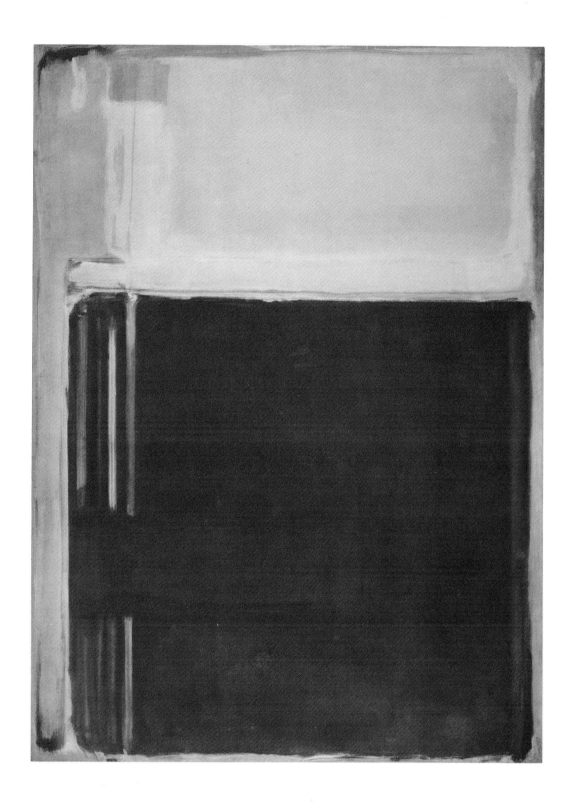

ROTHKO

19 *Untitled.* 1949
 Lent by the Estate of Mark Rothko,
 courtesy of Marlborough Gallery, Inc.

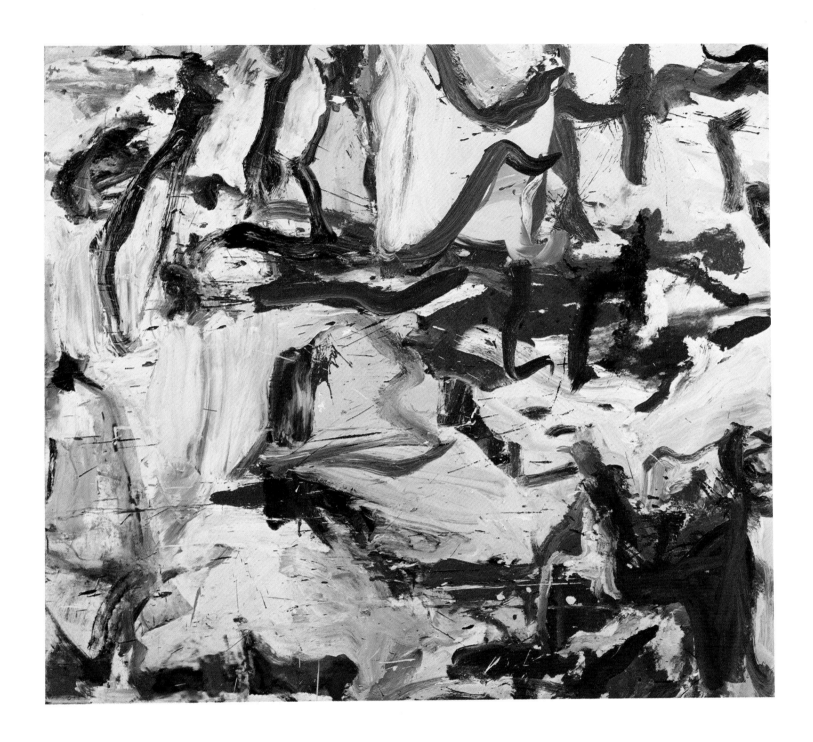

DE KOONING

23 *. . . Whose Name Was Writ in Water.* 1975
Courtesy Xavier Fourcade, Inc., New York

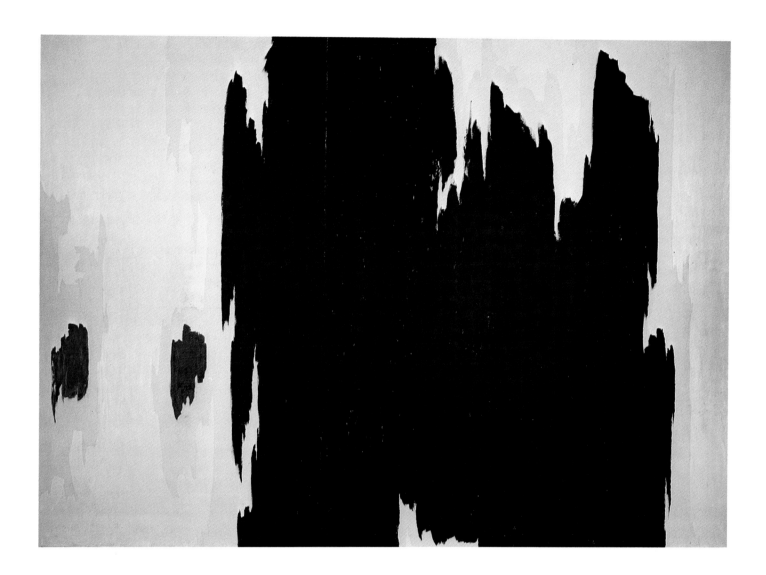

STILL

25 *1956-H.* 1956
Courtesy Marlborough Gallery, New York

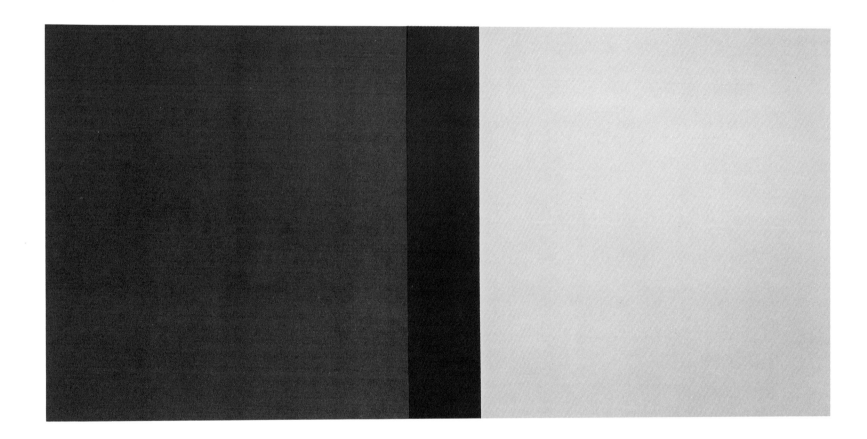

NEWMAN

27 *Who's Afraid of Red, Yellow and Blue IV.* 1969-70
Collection Annalee Newman

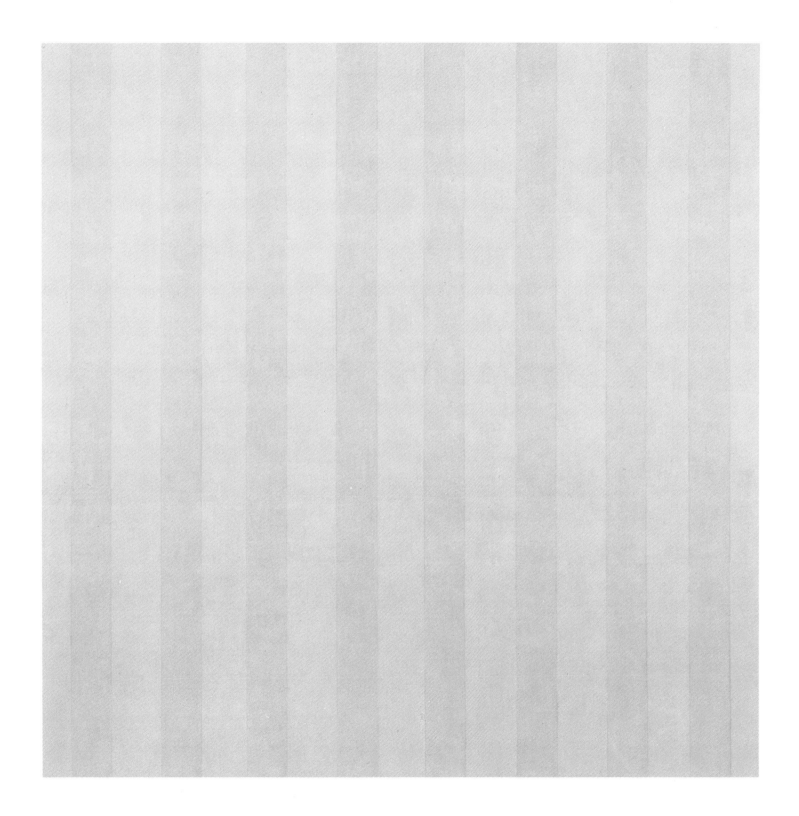

MARTIN

34 *Untitled #8.* 1975
Lent by The Pace Gallery, New York

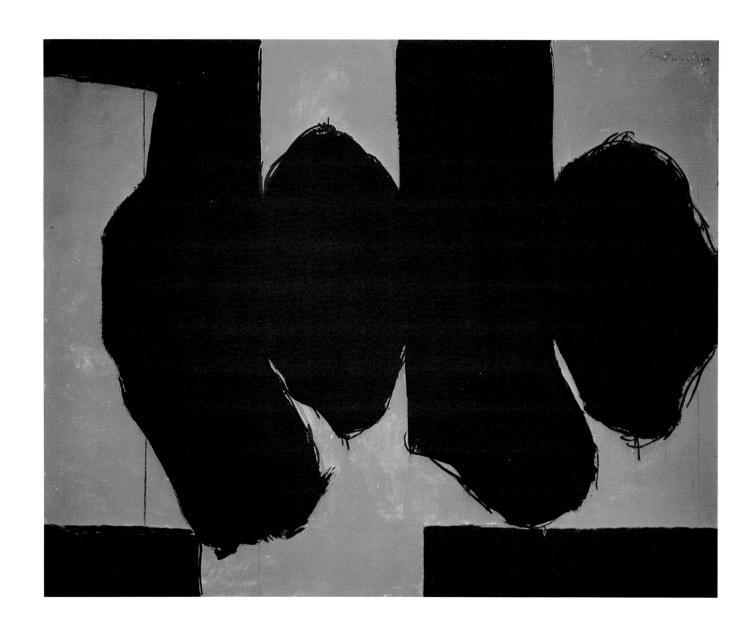

MOTHERWELL

38 *Elegy No. 131.* 1974
Lent by M. Knoedler & Co., Inc., New York

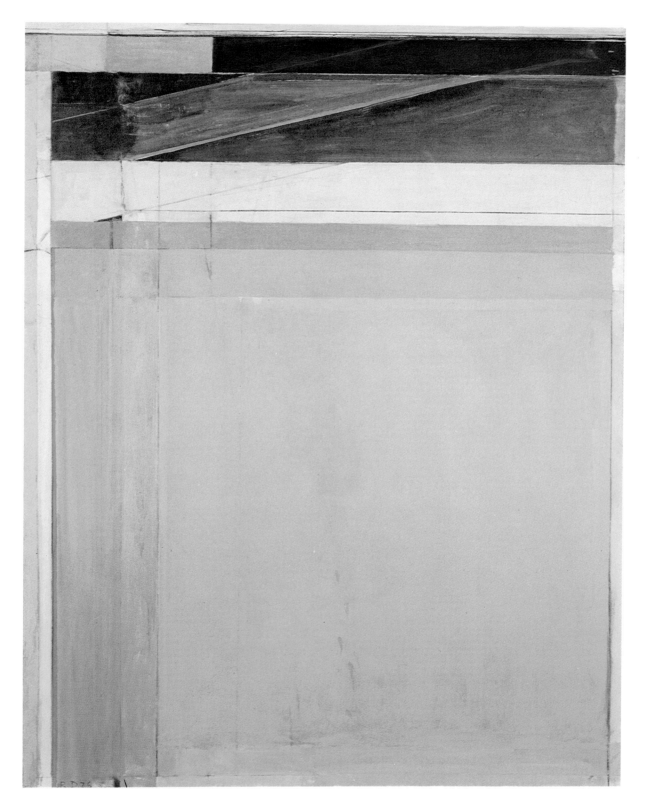

DIEBENKORN

39 *Ocean Park #90.* 1976
Collection Phyllis Diebenkorn

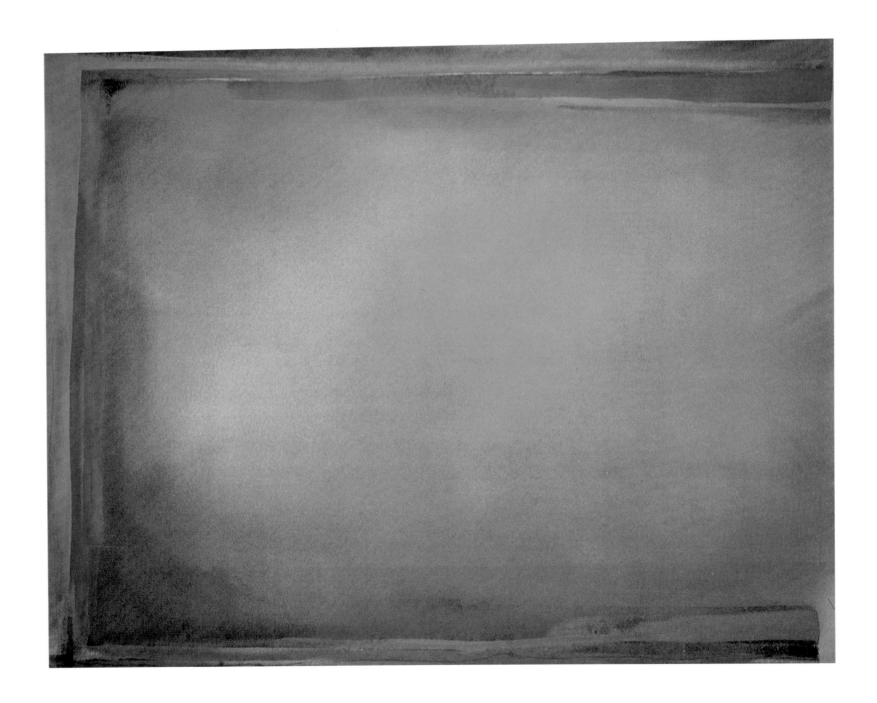

OLITSKI

40 *Optimum.* 1966
On extended loan to The Solomon R. Guggenheim Museum, New York,
from Harry N. Abrams Family Collection, New York

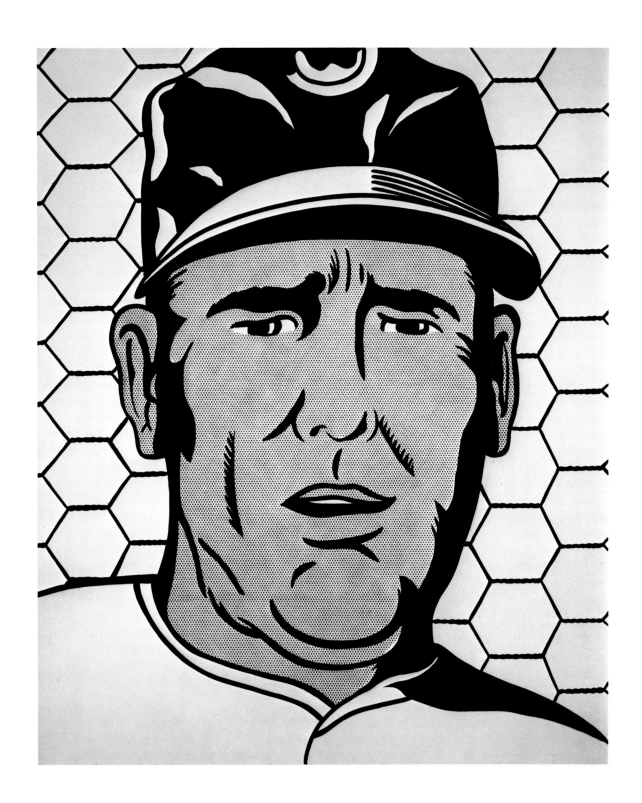

LICHTENSTEIN

44 *Baseball Manager.* 1963
Private Collection, New York

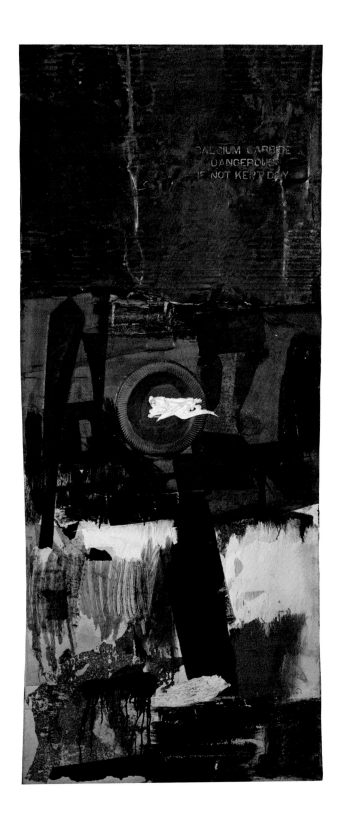

RAUSCHENBERG

48 *Forge.* 1959
Lent by Acquavella Contemporary Art, Inc., New York

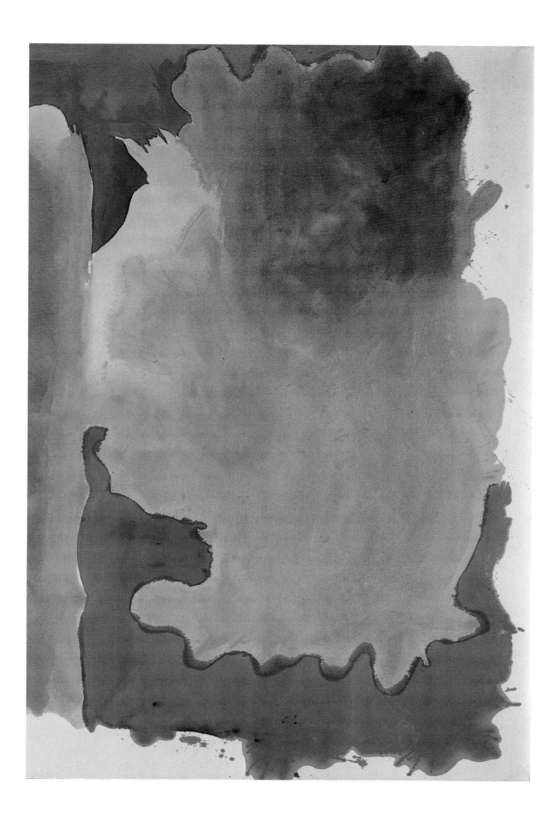

FRANKENTHALER

49 *Canal.* 1963
Collection The Solomon R. Guggenheim Museum, New York
Purchased with the aid of funds from the National Endowment for the Arts;
Matching Gift, Evelyn Sharp, New York

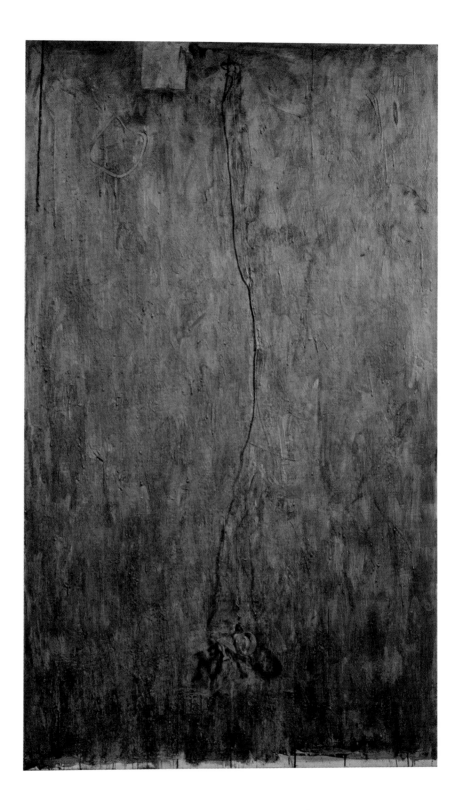

JOHNS

51 *NO.* 1961
Lent by the artist

STELLA

54 *Sinjerli Variation I.* 1968
On extended loan to The Solomon R. Guggenheim Museum, New York,
from Harry N. Abrams Family Collection, New York

Arshile Gorky: Works 1944-1948

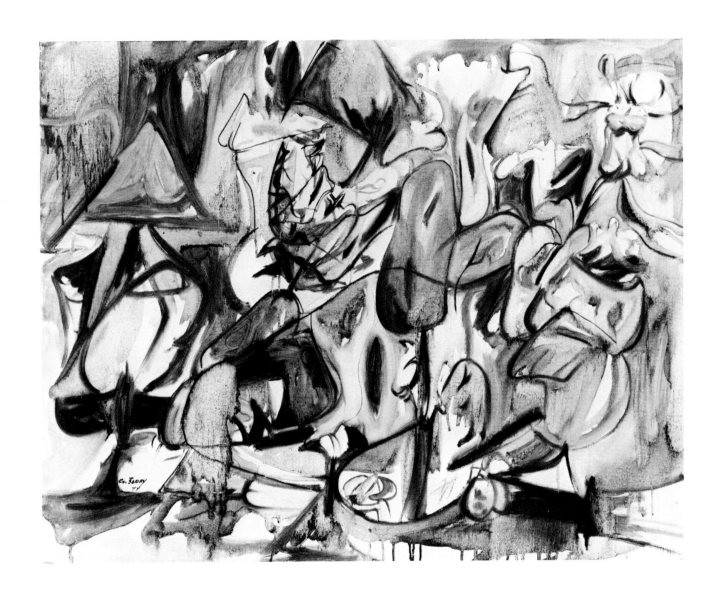

ARSHILE GORKY 1905-1948

*1 *The Leaf of the Artichoke Is an Owl.* 1944
 Oil on canvas, 28 x 36″
 Lent by Allan Stone and Harold Diamond

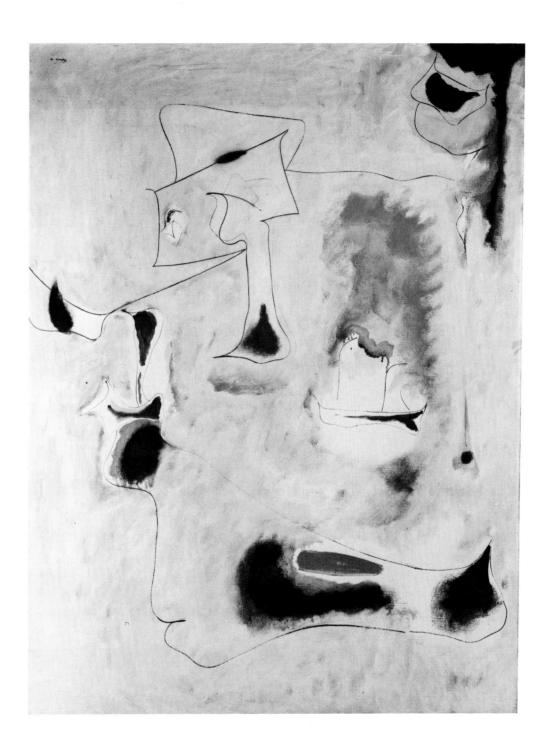

ARSHILE GORKY

2 *Charred Beloved I.* 1946
 Oil on canvas, 58⅝ x 39¾"
 Private Collection, Chicago, Illinois

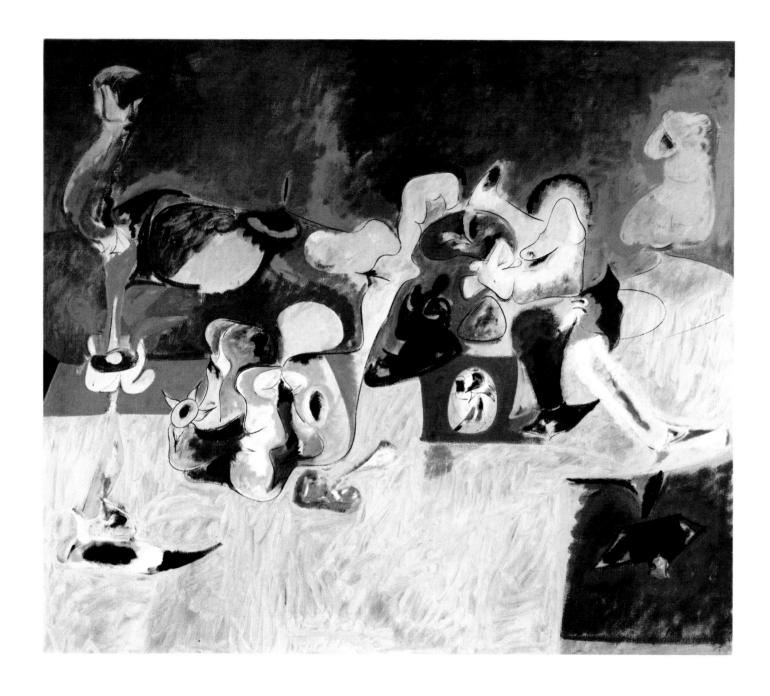

ARSHILE GORKY

3　*The Plough and The Song II.*　1946
Oil on canvas, 51⅞ x 61⅜"
Collection The Art Institute of Chicago,
Mr. and Mrs. Lewis L. Coburn Fund

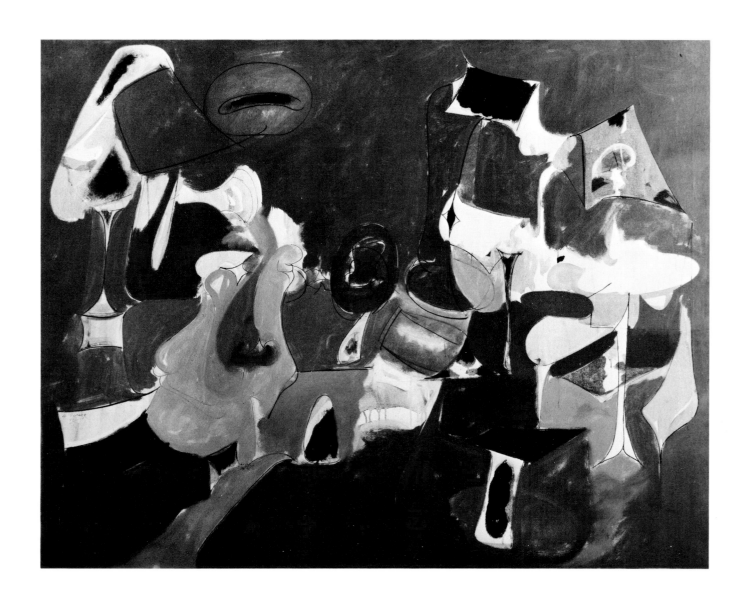

ARSHILE GORKY

4 *Soft Night.* 1947
 Oil on canvas, 38 x 50″
 Collection Joseph H. Hirshhorn

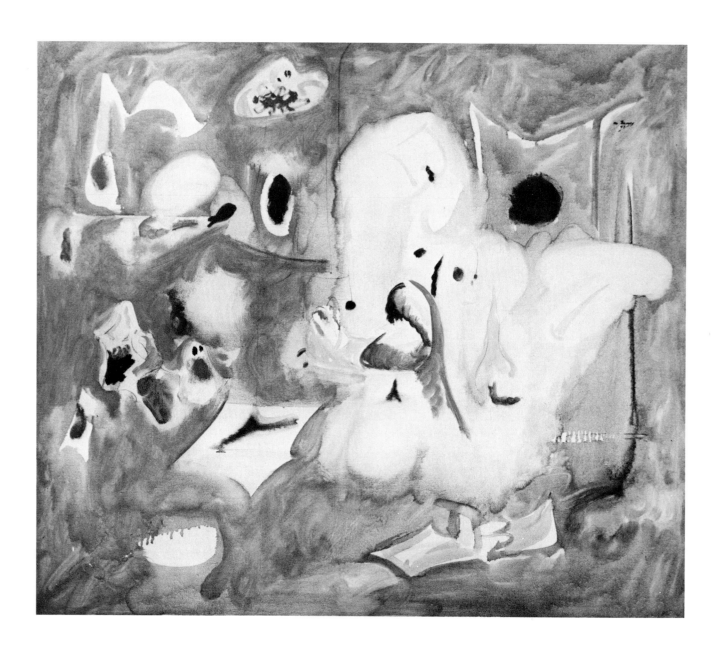

ARSHILE GORKY

5 *Summer Snow.* 1947
Oil on canvas, 30¼ x 36″
Collection Mr. and Mrs. Howard Wise, New York

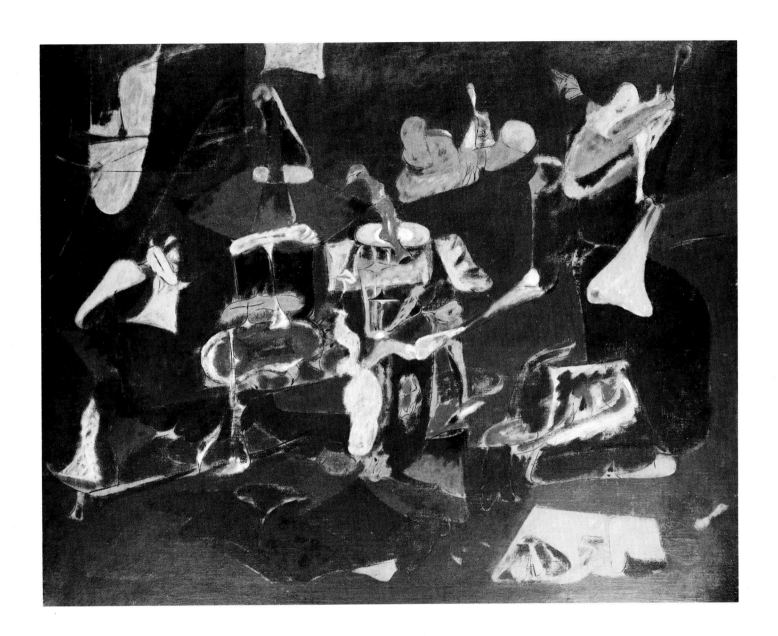

ARSHILE GORKY

6 *Dark Green Painting.* c. 1948
Oil on canvas, 43⅞ x 55⅞″
Collection Mrs. H. Gates Lloyd

Acquisition Priorities:

Aspects of Postwar Painting in America

42

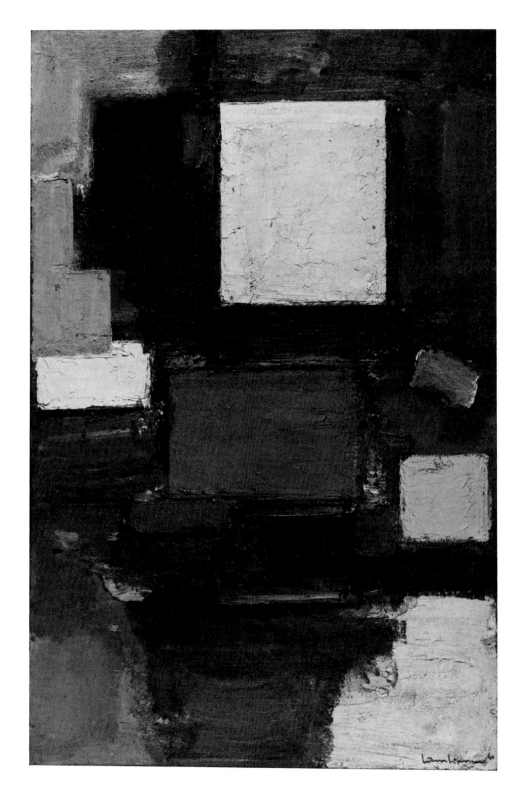

HANS HOFMANN 1880-1966

7 *The Gate.* 1960
Oil on canvas, 74⅝ x 48¼"
Collection The Solomon R. Guggenheim Museum, New York
62.1620

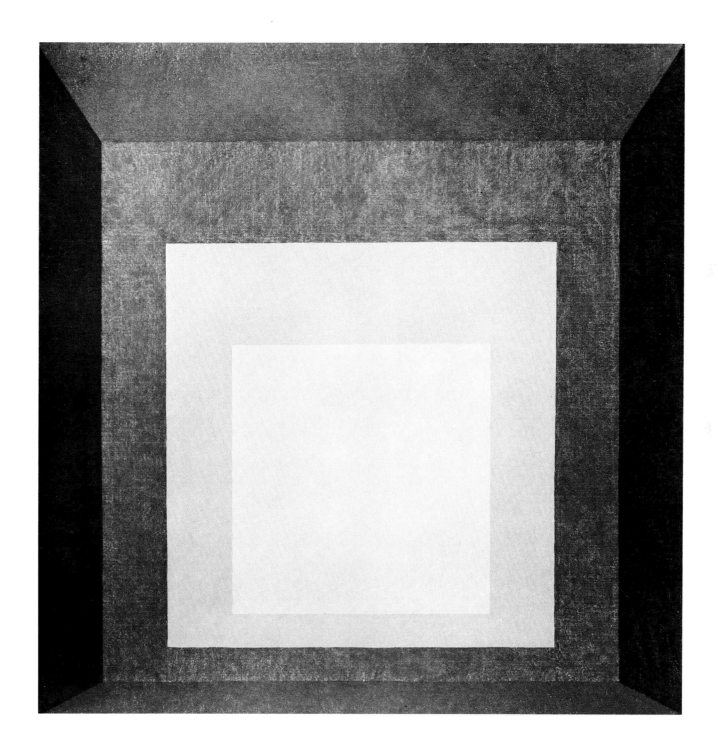

JOSEF ALBERS 1888-1976

8 *Homage to the Square: Apparition.* 1959
Oil on board, 47½ x 47½"
Collection The Solomon R. Guggenheim Museum, New York
61.1590

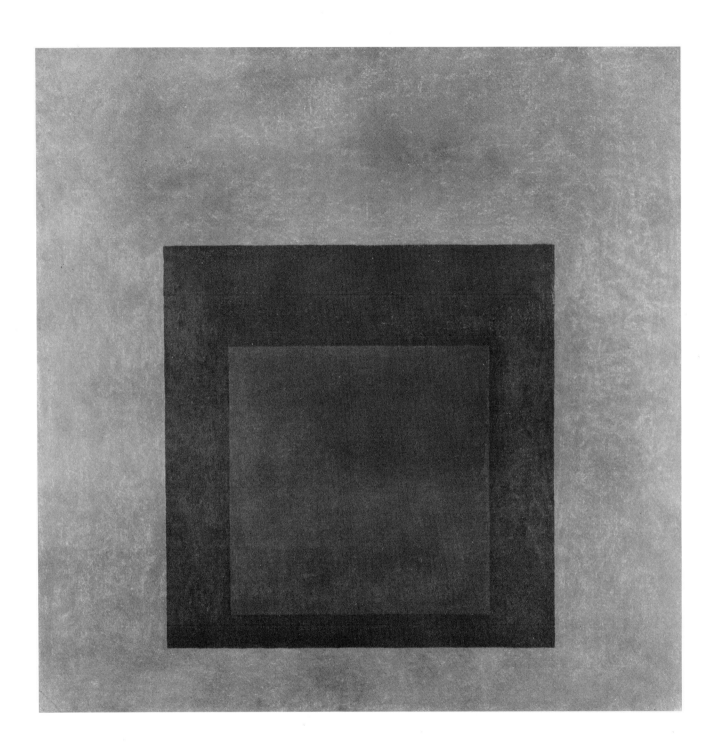

JOSEF ALBERS

8a *Homage to the Square: Late Blue Sky.* 1962
Oil on masonite, 48 x 48″
Collection Mr. and Mrs. Sidney Singer, New York

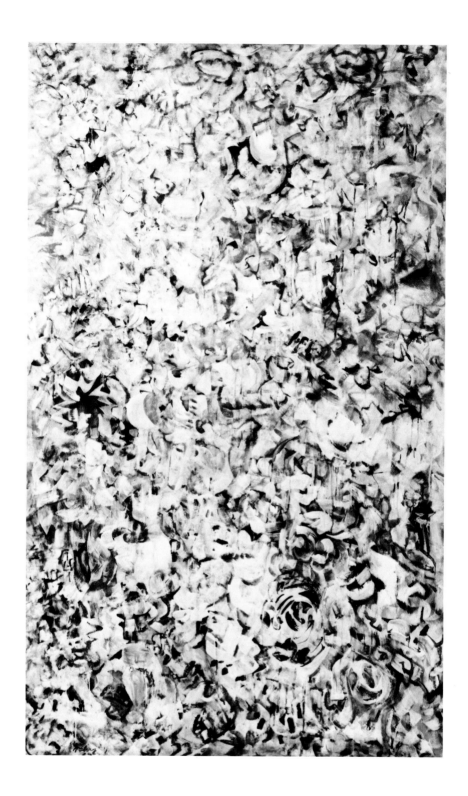

MARK TOBEY 1890-1976

*9 *Appearances in Time.* 1962
Oil on canvas, 57 x 34½"
Lent by Willard Gallery

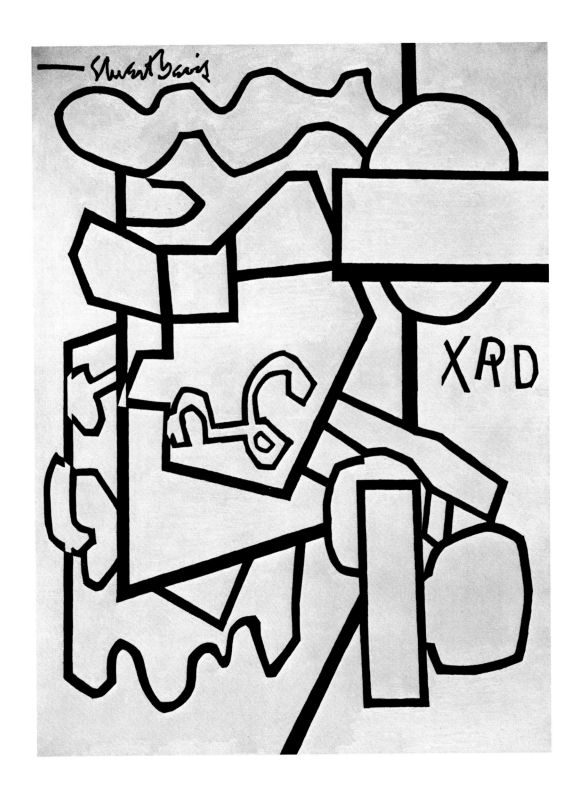

STUART DAVIS 1894-1964

10 *Cliché.* 1955
Oil on canvas, 56¼ x 42″
Collection The Solomon R. Guggenheim Museum, New York
55.1428

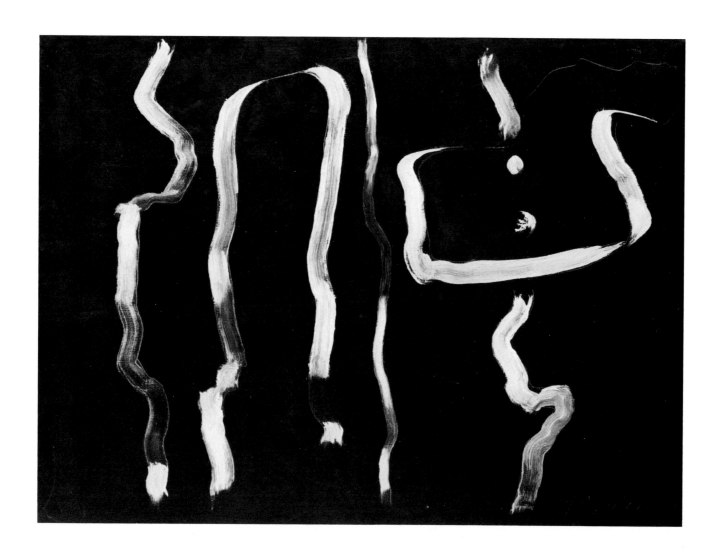

BRADLEY WALKER TOMLIN 1899-1953

11 *Tension by Moonlight.* 1948
Oil on canvas, 32 x 44″
Lent by Betty Parsons Gallery, New York

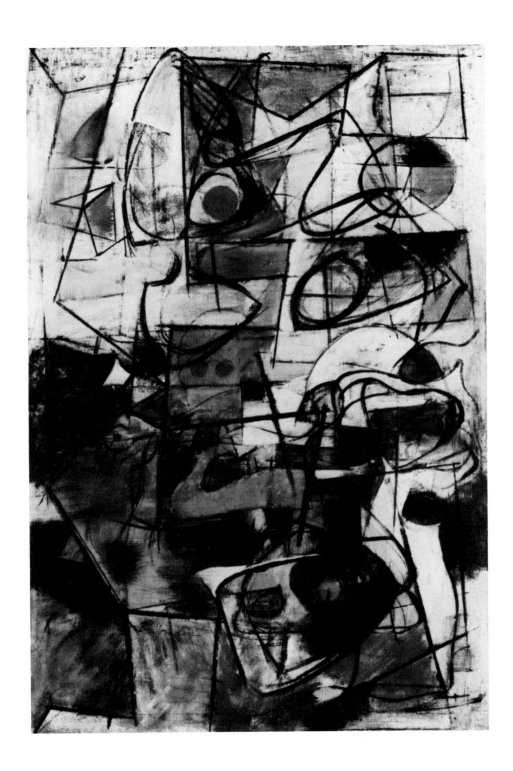

BRADLEY WALKER TOMLIN

*12 *No. 10-A.* 1949
Oil on canvas, 46 x 31″
Private Collection, New York

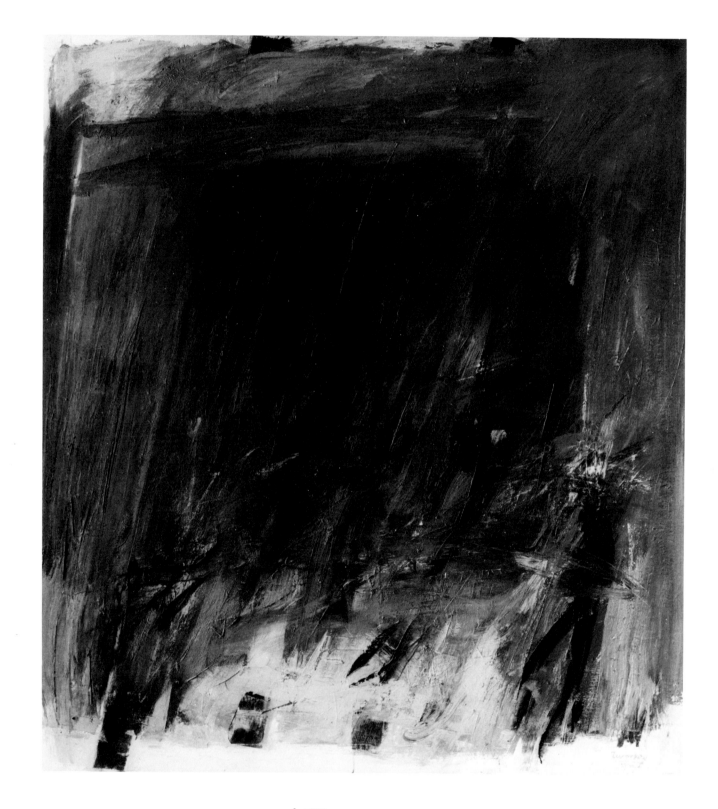

JACK TWORKOV b.1900

*13 *Red Lode.* 1959-60
Oil on canvas, 68 x 61″
Lent by Nancy Hoffman Gallery, New York

JACK TWORKOV

14 *Diptych II.* 1972
Oil on canvas, two panels, each 76 x 76"
Collection The Solomon R. Guggenheim Museum, New York,
Purchased with the aid of funds from the National Endowment
for the Arts; Matching Gift, Mrs. Leo Simon, New York
72.2021

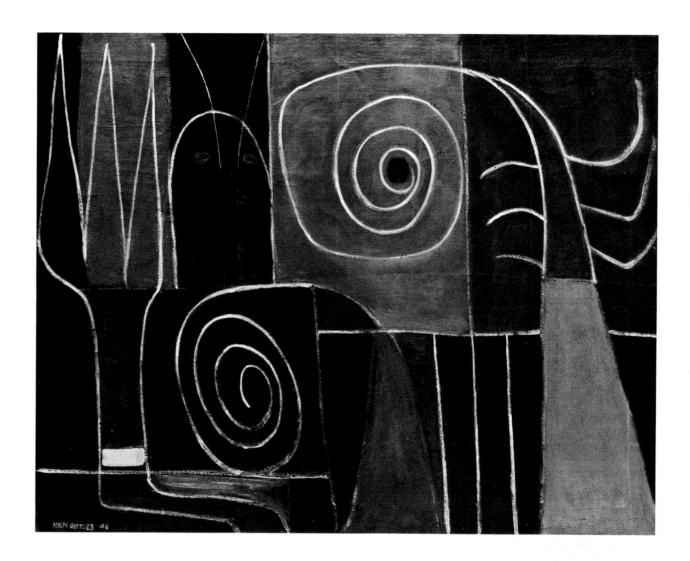

ADOLPH GOTTLIEB 1903-1974

15 *Enigma.* 1946
Oil on canvas, 28 x 35½″
Collection The Solomon R. Guggenheim Museum, New York
48.1172x518

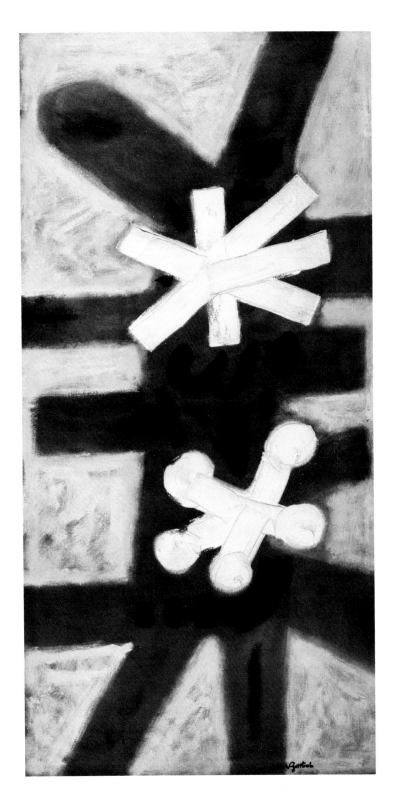

ADOLPH GOTTLIEB

16 *W.* 1954
 Oil with sand on canvas, 72 x 36″
 Collection The Solomon R. Guggenheim Museum, New York
 54.1401

ADOLPH GOTTLIEB

*17 *Mist.* 1961
Oil on canvas, 72 x 48″
Collection Susan Morse Hilles

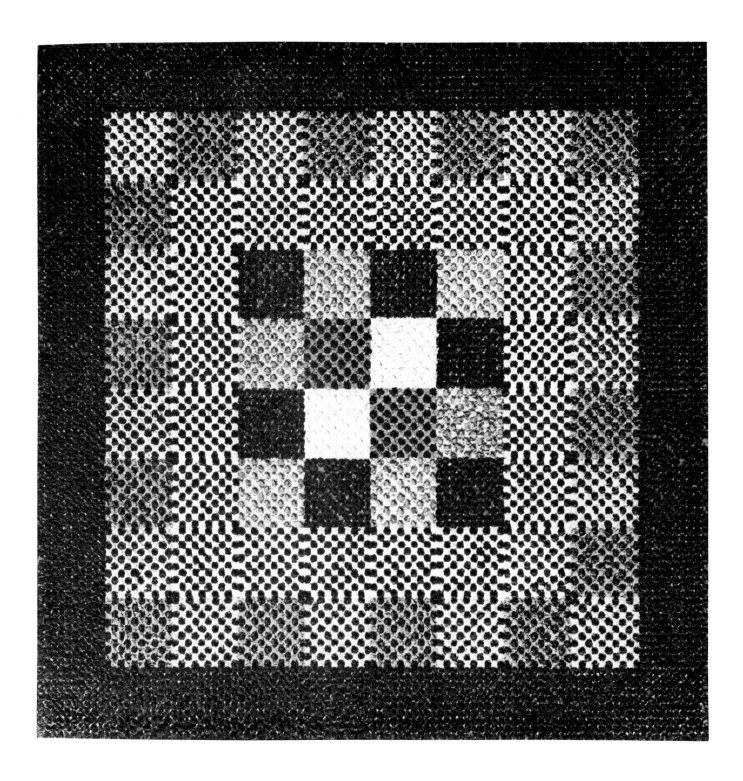

ALFRED JENSEN b.1903

18 *Uaxactun.* 1964
Oil on canvas, 50¼ x 50¼″
Collection The Solomon R. Guggenheim Museum, New York
72.2018

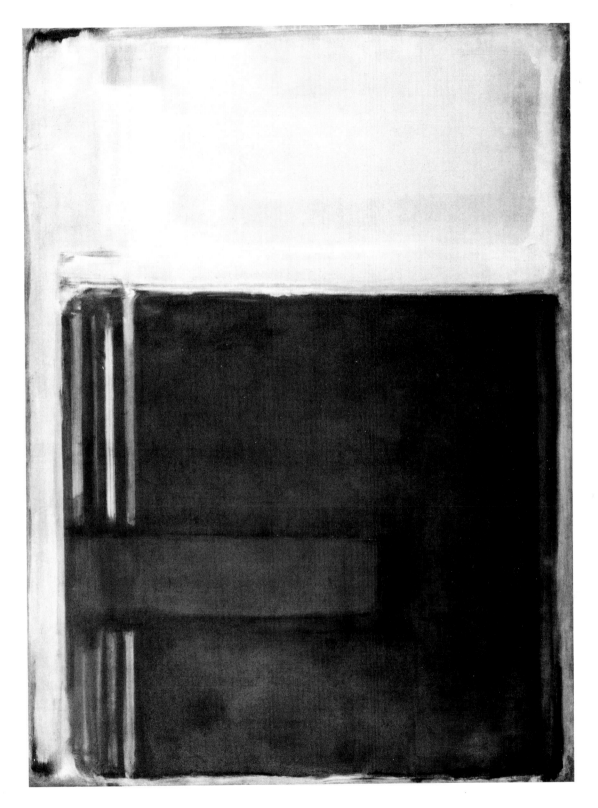

MARK ROTHKO 1903-1970

*19 *Untitled.* 1949
 Oil on canvas, 98 x 65″
 Lent by the Estate of Mark Rothko, courtesy of Marlborough
 Gallery, Inc.

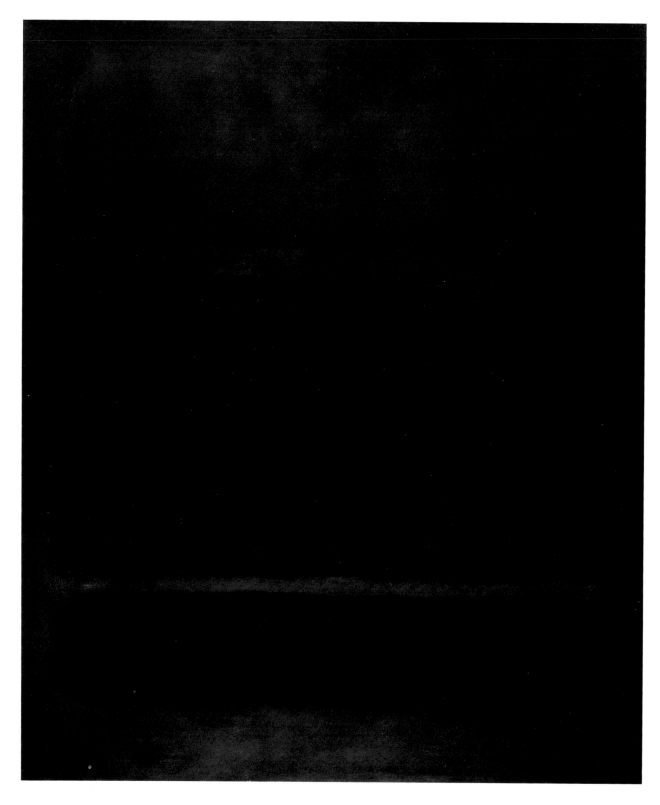

MARK ROTHKO

20 *Brown, Black on Maroon.* 1957
Oil on canvas, 91½ x 76″
Lent by the Estate of Mark Rothko, courtesy of Marlborough
Gallery, Inc.

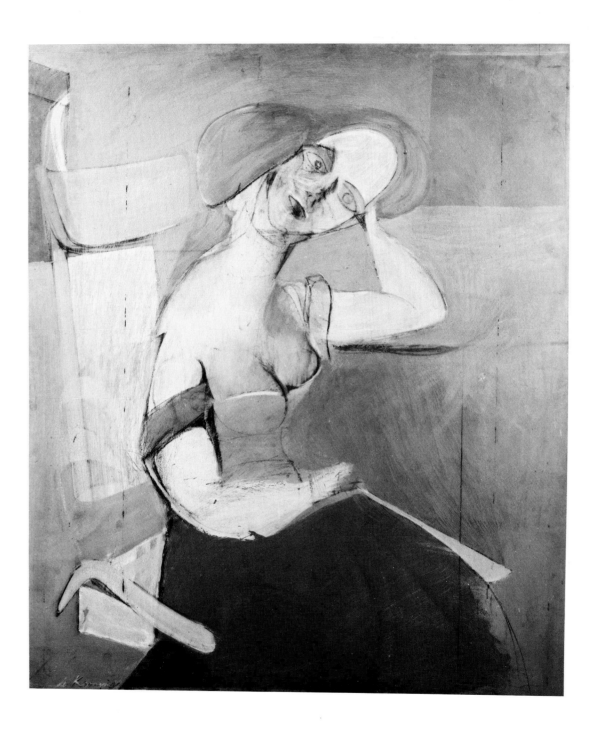

WILLEM DE KOONING b.1904

21 *Woman Sitting.* 1943-44
Oil and charcoal on composition board, 48¼ x 42″
Courtesy Xavier Fourcade, Inc., New York

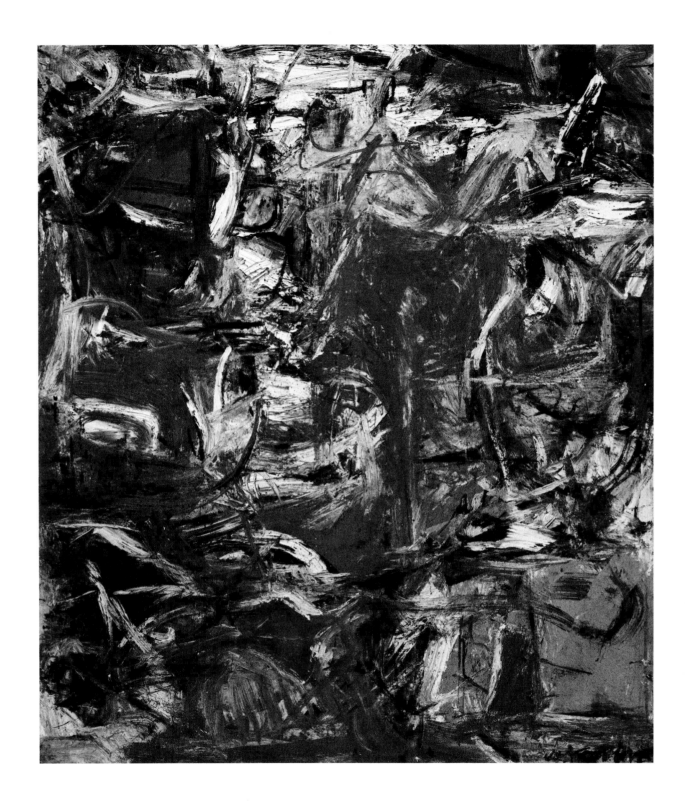

WILLEM DE KOONING

22 *Composition.* 1955
Oil on canvas, 79⅛ x 69⅛″
Collection The Solomon R. Guggenheim Museum, New York
55.1419

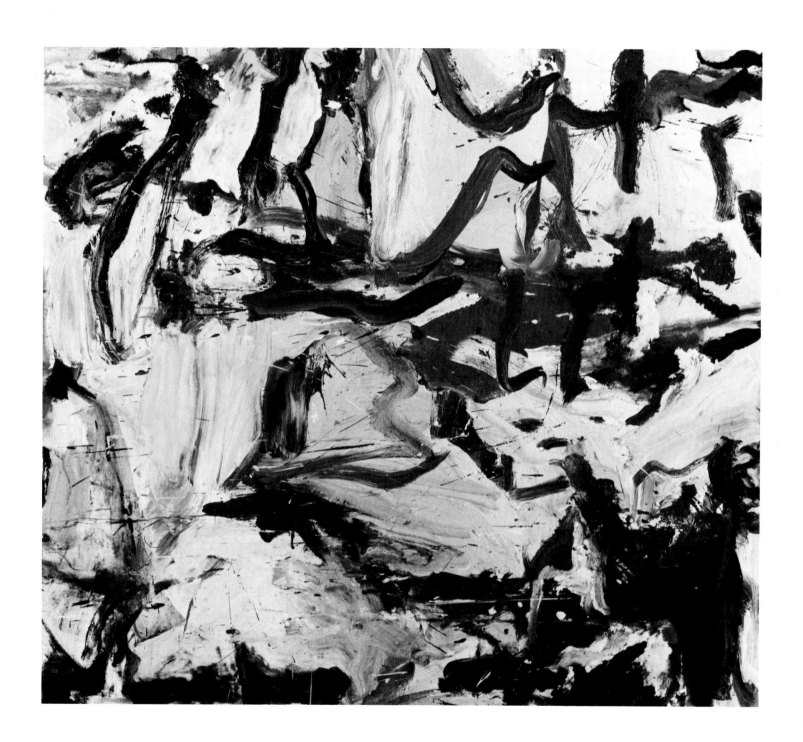

WILLEM DE KOONING

*23 . . . *Whose Name Was Writ in Water*. 1975
Oil on canvas, 77 x 88″
Courtesy Xavier Fourcade, Inc., New York

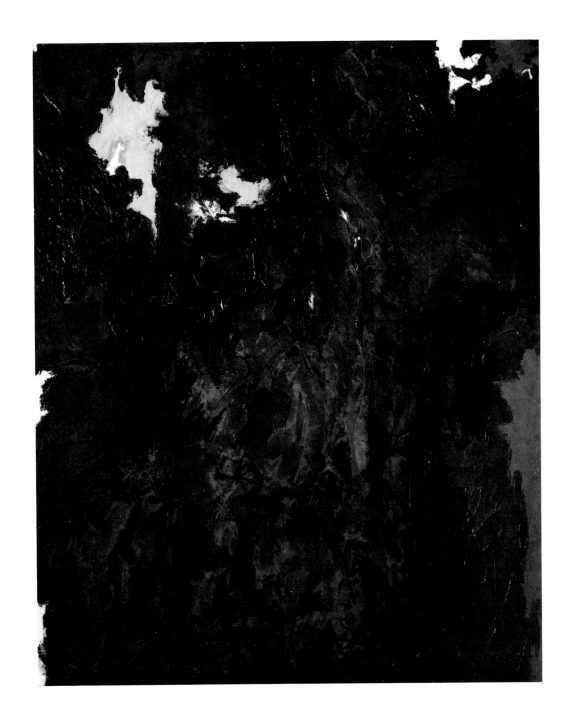

CLYFFORD STILL b.1904

24 *No. 3. 1951*
Oil on canvas, 48 x 39″
Collection Mr. and Mrs. S. I. Newhouse, Jr.

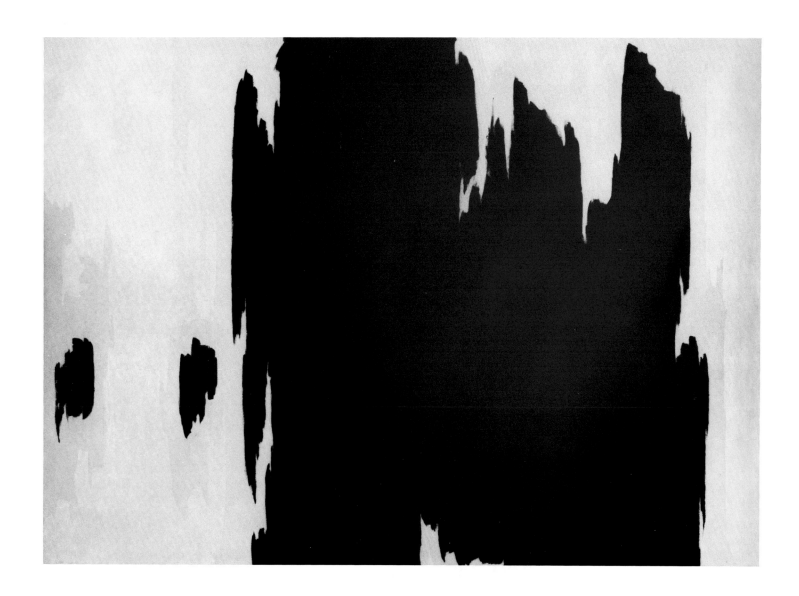

CLYFFORD STILL

*25 *1956-H.* 1956
Oil on canvas, 113½ x 161½"
Courtesy Marlborough Gallery, New York

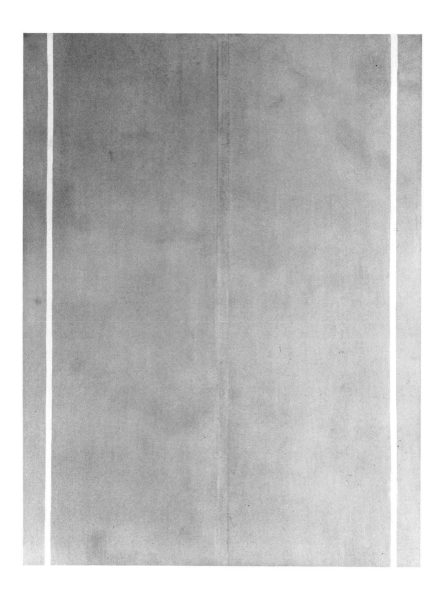

BARNETT NEWMAN 1905-1970

26 *Yellow Painting.* 1949
Oil on canvas, 67 x 52″
Collection Annalee Newman

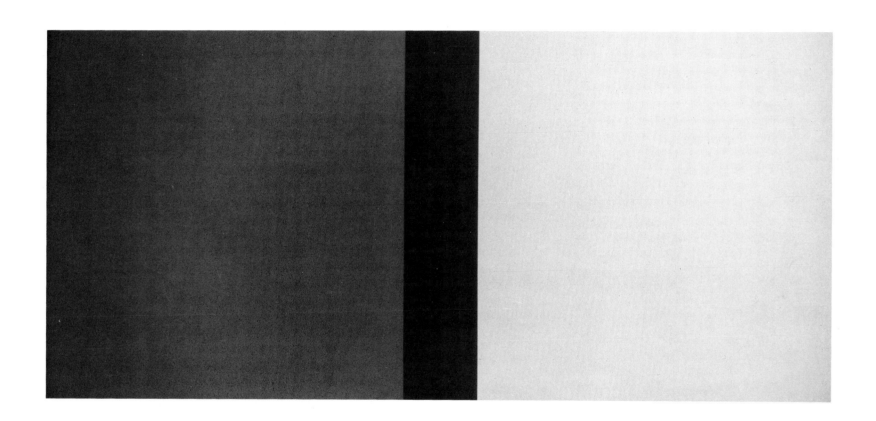

BARNETT NEWMAN

***27** *Who's Afraid of Red, Yellow and Blue IV.* 1969-70
Acrylic on canvas, 108 x 238″
Collection Annalee Newman

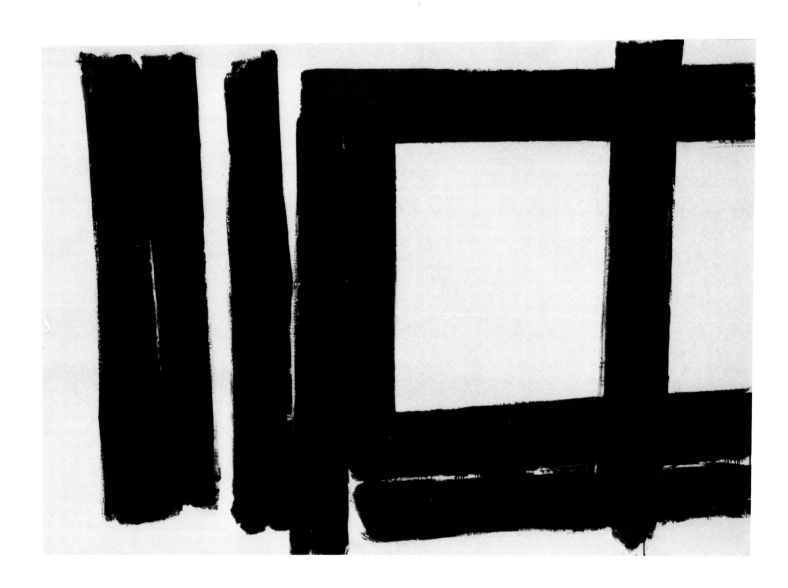

FRANZ KLINE 1910-1962

28 *Painting No. 7.* 1952
Oil on canvas, 57½ x 81¾"
Collection The Solomon R. Guggenheim Museum, New York
54.1403

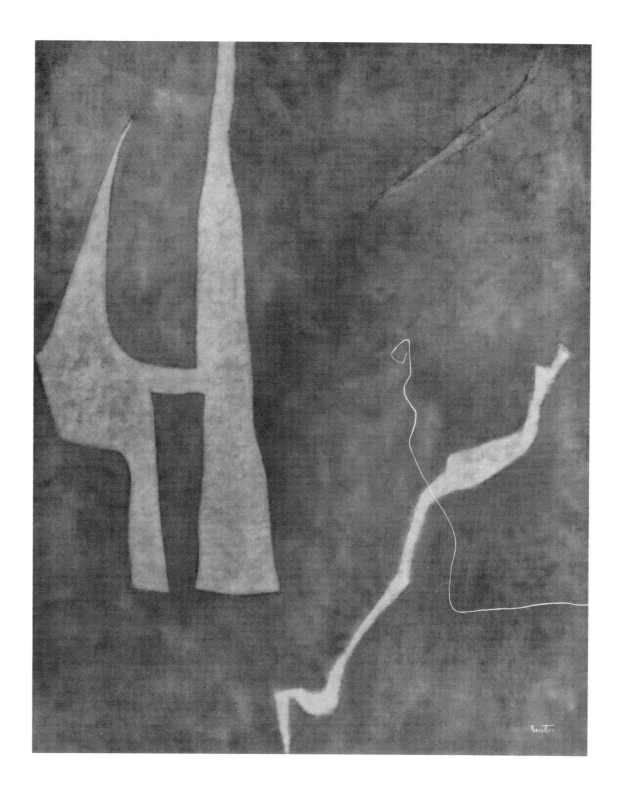

WILLIAM BAZIOTES 1912-1963

29 *Dusk.* 1958
 Oil on canvas, 60⅜ x 48¼″
 Collection The Solomon R. Guggenheim Museum, New York
 59.1544

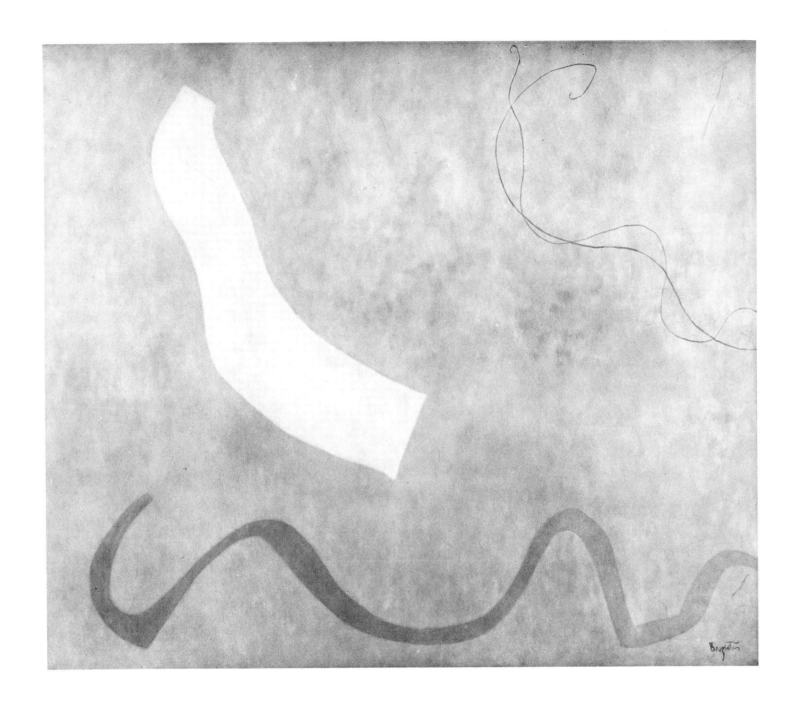

WILLIAM BAZIOTES

30 *Aquatic.* 1961
Oil on canvas, 66 x 78⅛″
Collection The Solomon R. Guggenheim Museum, New York
63.1630

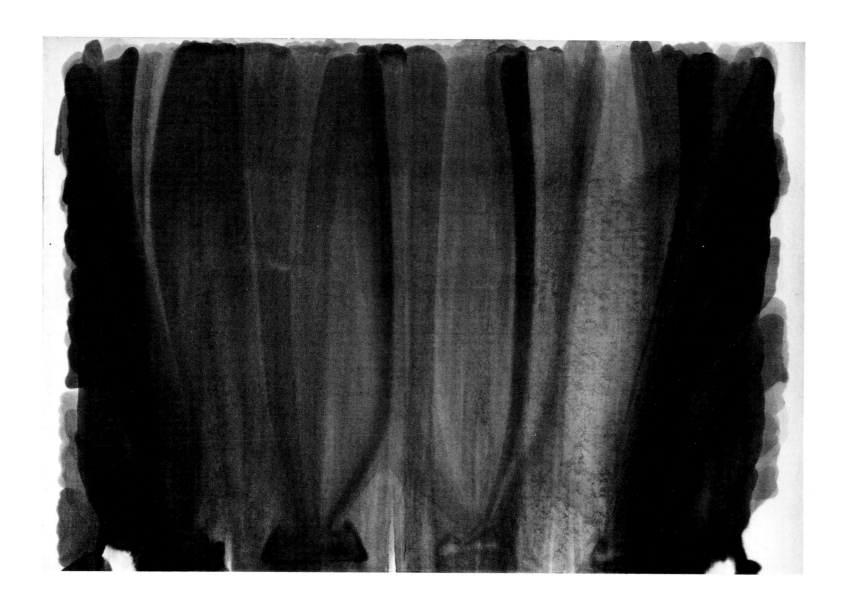

MORRIS LOUIS 1912-1962

31 *Saraband.* 1959
Acrylic on canvas, 101⅛ x 149″
Collection The Solomon R. Guggenheim Museum, New York
64.1685

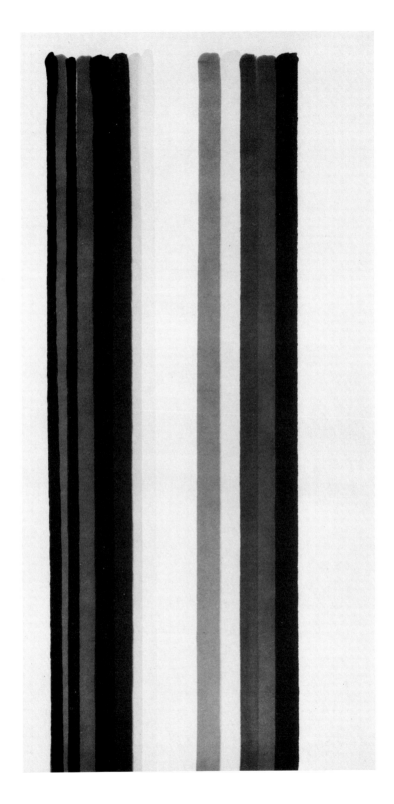

MORRIS LOUIS

32 *No. 1-68.* 1961-62
Acrylic on canvas, 83¾ x 42″
Collection The Solomon R. Guggenheim Museum, New York
68.1846

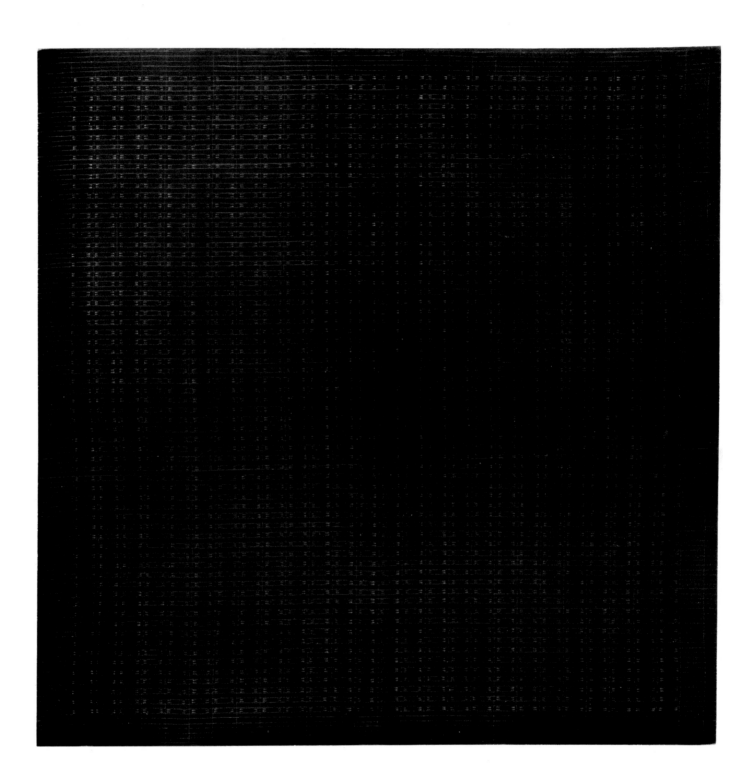

AGNES MARTIN b.1912

33 *White Flower.* 1960
Oil on canvas, 71⅞ x 72"
Collection The Solomon R. Guggenheim Museum, New York,
Anonymous Gift, 1963
63.1653

AGNES MARTIN

*34 *Untitled #8.* 1975
Acrylic, pencil and Shiva gesso on canvas, 72 x 72″
Lent by The Pace Gallery, New York

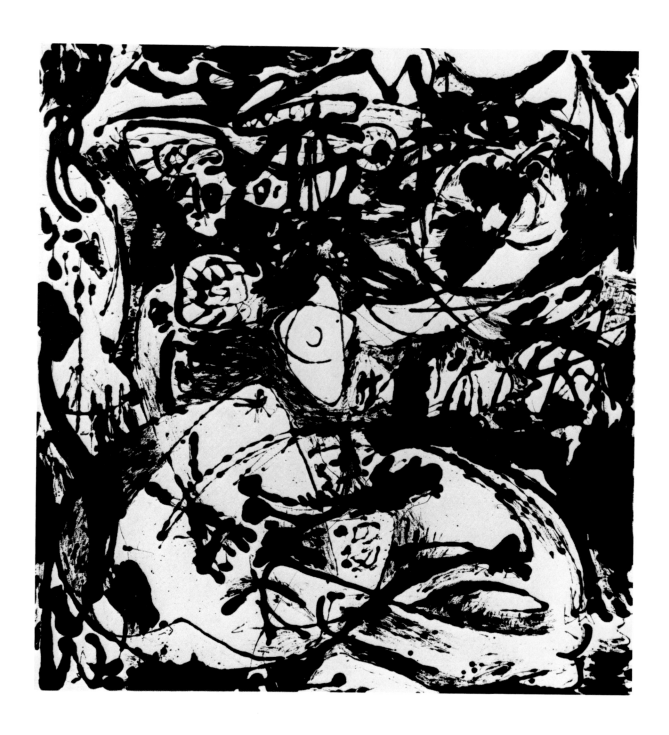

JACKSON POLLOCK 1912-1956

34a *Number 18.* 1951
Enamel on canvas, 58¾ x 55½″
Collection Edward F. Dragon

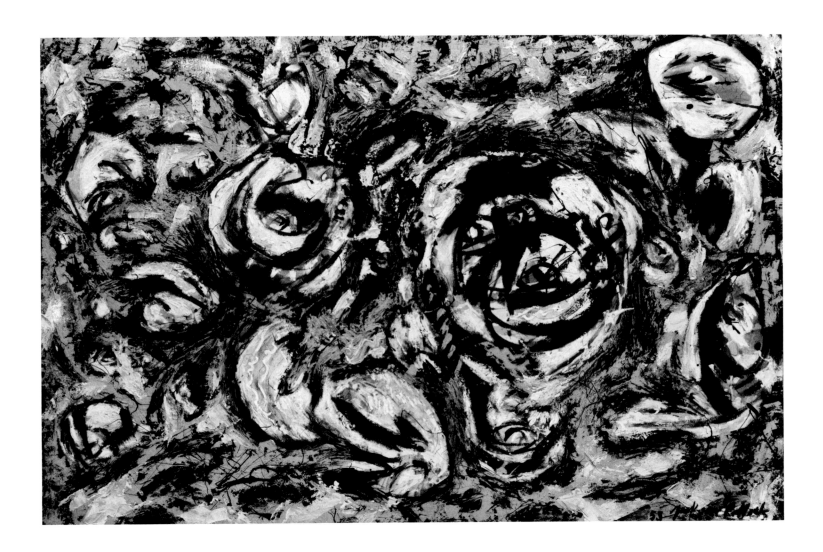

JACKSON POLLOCK

35 *Ocean Greyness.* 1953
Oil on canvas, 57¾ x 90⅛"
Collection The Solomon R. Guggenheim Museum, New York
54.1408

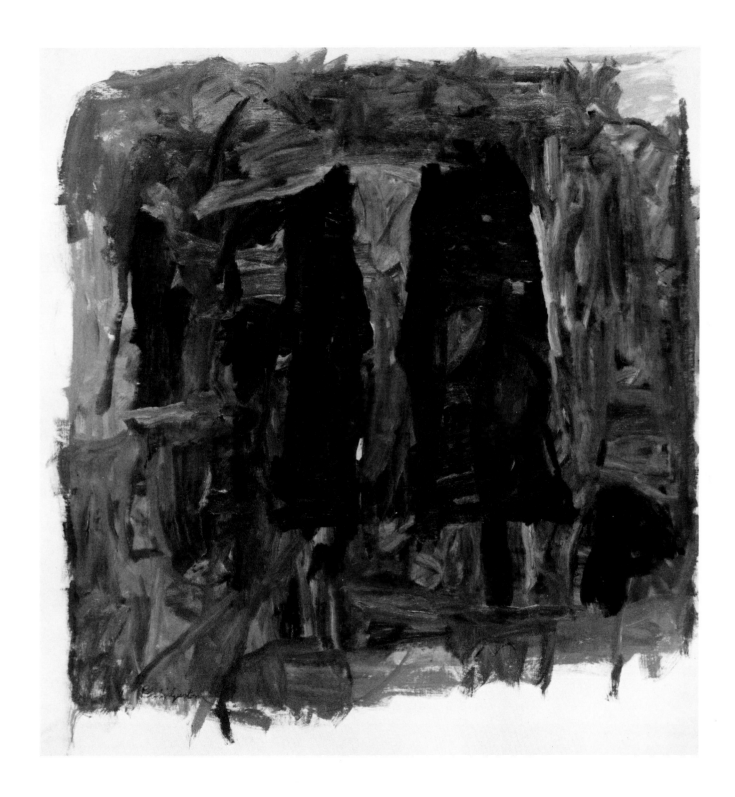

PHILIP GUSTON b.1913

36 *Duo.* 1961
Oil on canvas, 72¼ x 68″
Collection The Solomon R. Guggenheim Museum, New York
64.1683

AD REINHARDT 1913-1967

37 *No. 33 (Abstract Painting, 60 x 60, 1963).* 1963
Oil on canvas, 60 x 60"
Collection Fred Mueller, New York

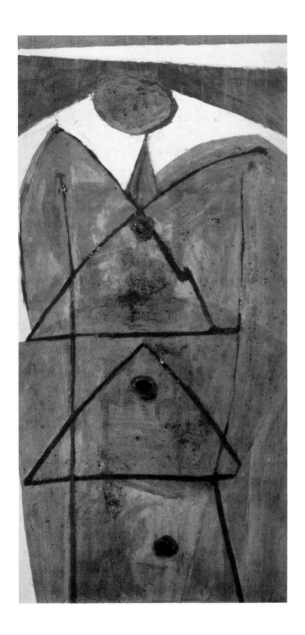

ROBERT MOTHERWELL b.1915

37a *The Homely Protestant.* 1948
 Oil on masonite, 47½ x 23½"
 Collection Mr. and Mrs. John Murray Cuddihy, courtesy
 M. Knoedler & Co., Inc., New York

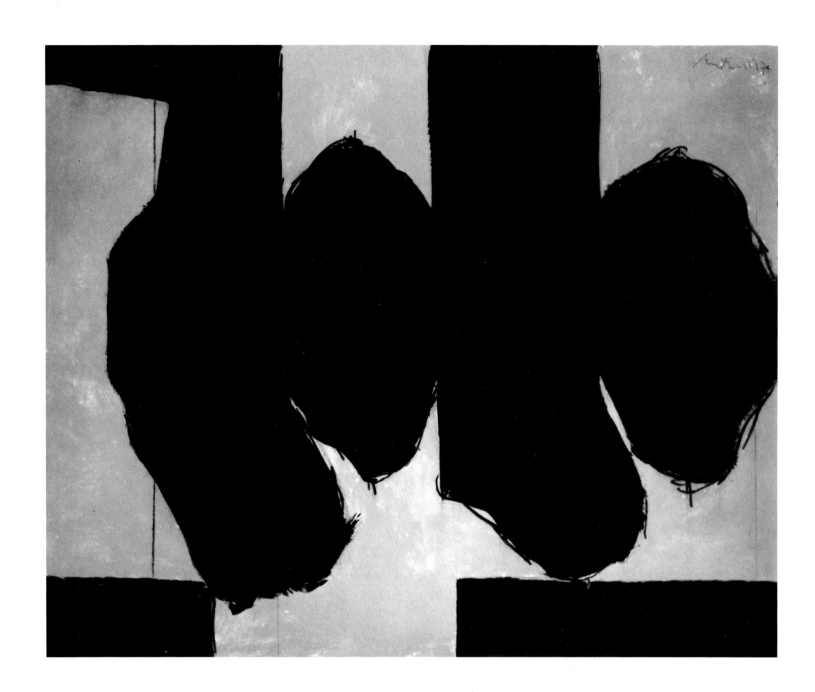

ROBERT MOTHERWELL

*38 *Elegy No. 131.* 1974
Acrylic and charcoal on oil-sized canvas, 96 x 120″
Lent by M. Knoedler & Co., Inc., New York

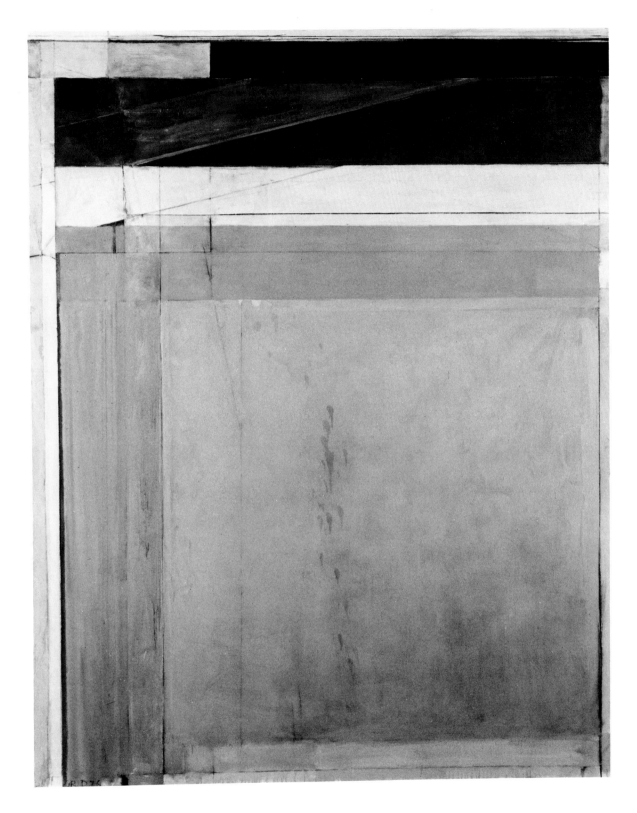

RICHARD DIEBENKORN b.1922

*39 *Ocean Park #90.* 1976
 Oil on canvas, 100 x 81"
 Collection Phyllis Diebenkorn

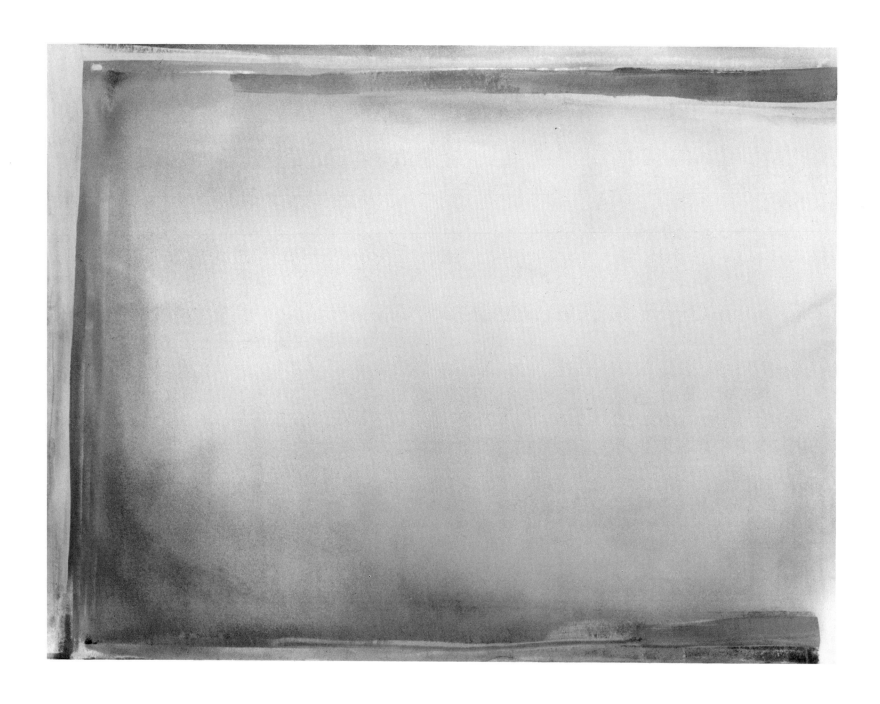

JULES OLITSKI b. 1922

*40 *Optimum*, 1966
Acrylic on canvas, 116¼ x 152″
On extended loan to The Solomon R. Guggenheim Museum,
New York, from Harry N. Abrams Family Collection, New York

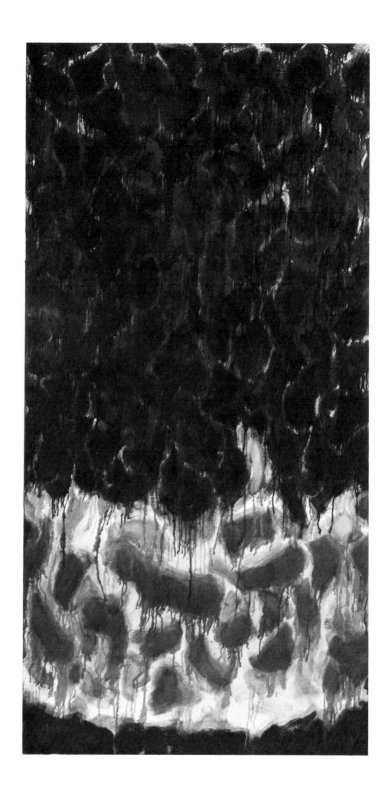

SAM FRANCIS b. 1923

41 *Red and Black.* 1954
Oil on canvas, 76⅞ x 38⅛"
Collection The Solomon R. Guggenheim Museum, New York
56.1442

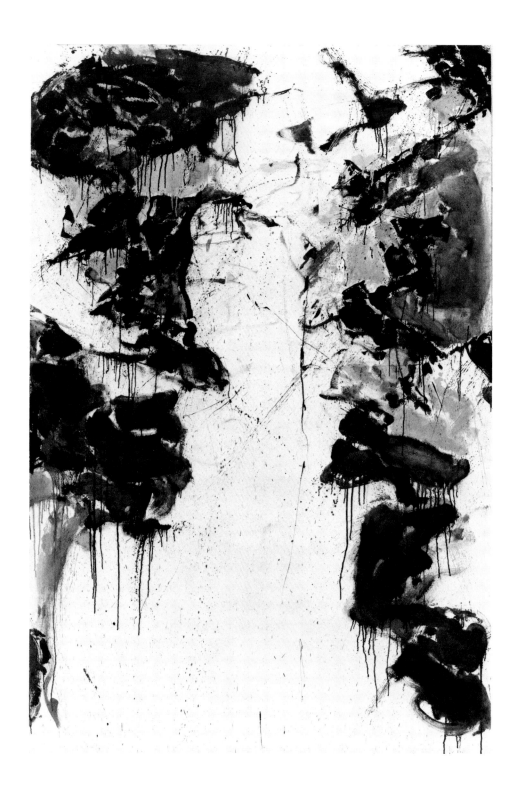

SAM FRANCIS

42 *Shining Back.* 1958
Oil on canvas, 79⅜ x 53⅛"
Collection The Solomon R. Guggenheim Museum, New York
59.1560

ELLSWORTH KELLY b.1923

43 *Blue, Green, Yellow, Orange, Red.* 1966
Acrylic on canvas, five panels, each 60 x 48″
Collection The Solomon R. Guggenheim Museum, New York
67.1833

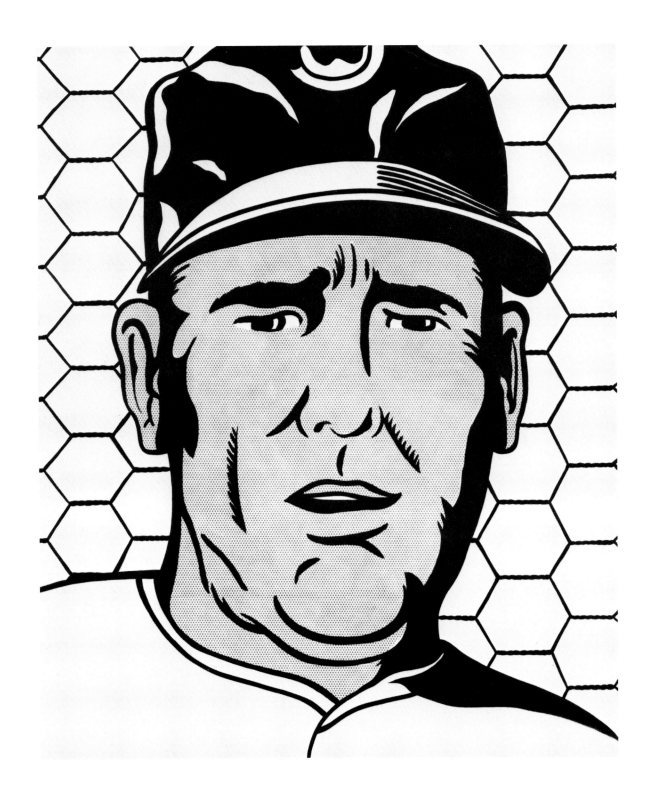

ROY LICHTENSTEIN b.1923

***44** *Baseball Manager.* 1963
Magna on canvas, 68 x 58″
Private Collection, New York

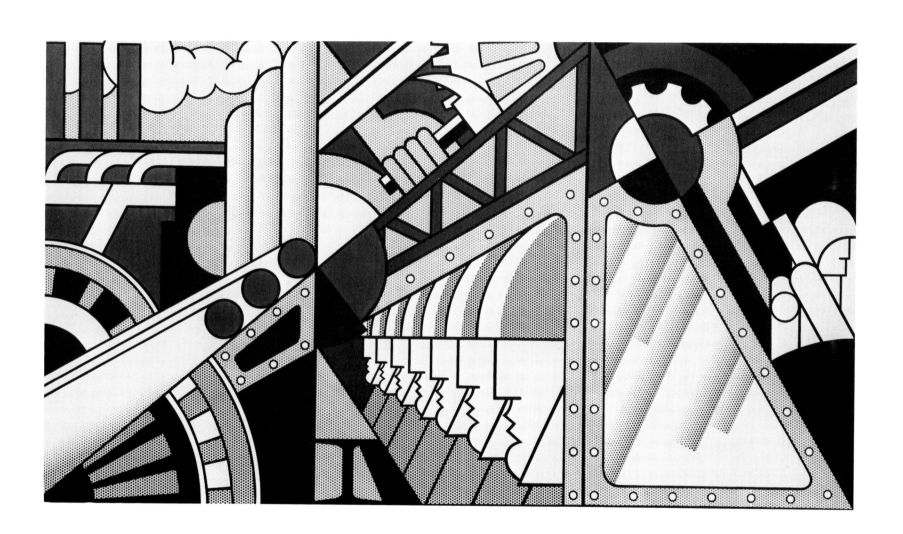

ROY LICHTENSTEIN

45 *Preparedness.* 1969
Magna on canvas, three panels, each 120 x 72″
Collection The Solomon R. Guggenheim Museum, New York
69.1885.1-3

KENNETH NOLAND b.1924

45a *And Half.* 1959
Magna on canvas, 69 x 69″
Collection Joanne du Pont, New York

KENNETH NOLAND

46 *April Tune*. 1969
Acrylic emulsion on canvas, 65¾ x 124⅛″
Collection The Solomon R. Guggenheim Museum, New York
69.1915

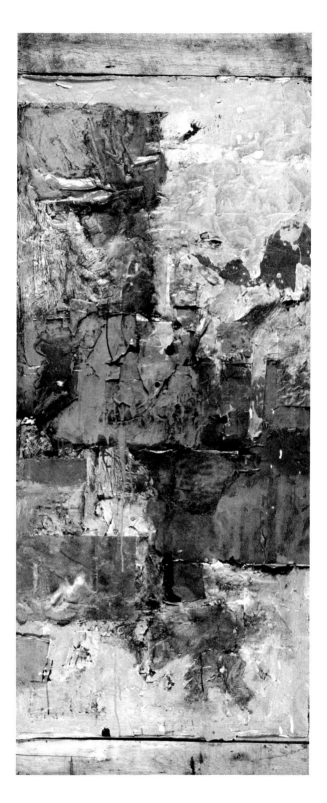

ROBERT RAUSCHENBERG b.1925

47 *Red Painting.* 1953
Combine, 79 x 33⅛″
Collection The Solomon R. Guggenheim Museum, New York,
Gift, Walter K. Gutman, New York
63.1688

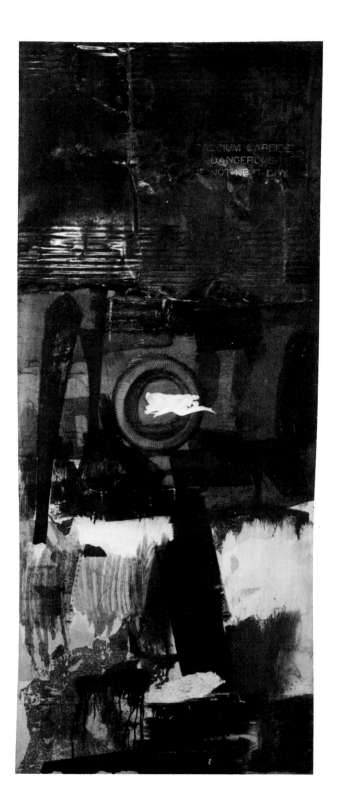

ROBERT RAUSCHENBERG

*48 *Forge.* 1959
Combine, 73 x 31″
Lent by Acquavella Contemporary Art, Inc., New York

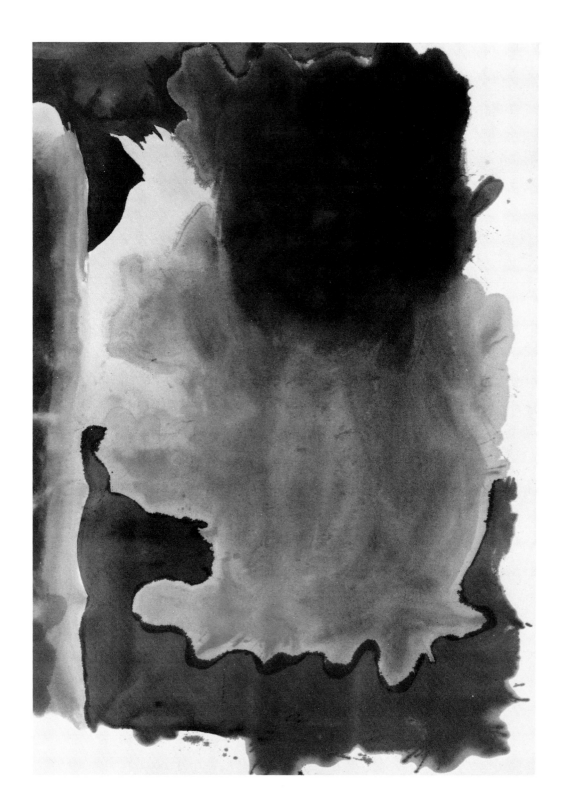

HELEN FRANKENTHALER b.1928

*49 *Canal.* 1963
Acrylic on canvas, 81 x 57½"
Collection The Solomon R. Guggenheim Museum, New York,
Purchased with the aid of funds from the National Endowment
for the Arts; Matching Gift, Evelyn Sharp, New York
76.2225

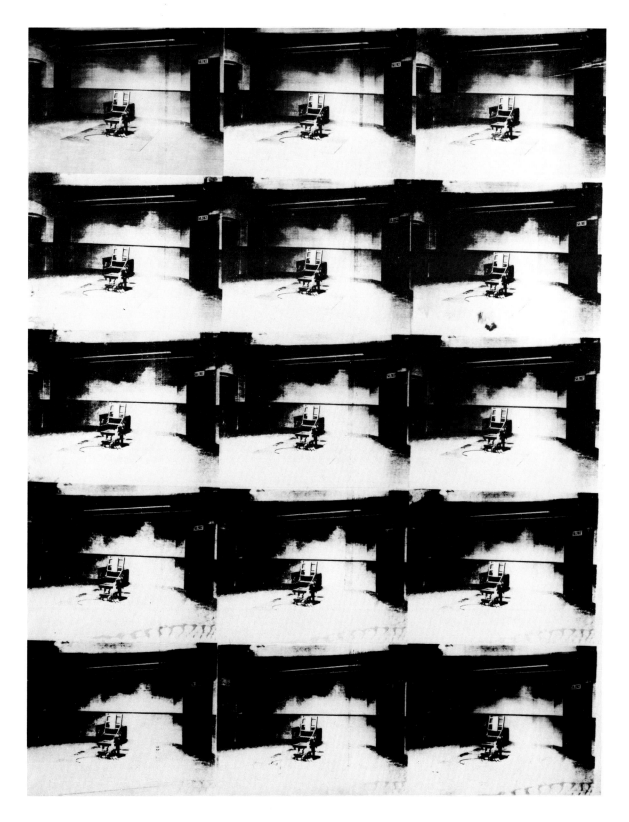

ANDY WARHOL b.1928

50 *Orange Disaster No. 5.* 1963
Oil on canvas, 106 x 82"
Collection The Solomon R. Guggenheim Museum, New York,
Gift, Harry N. Abrams Family Collection, New York, 1974
75.2118

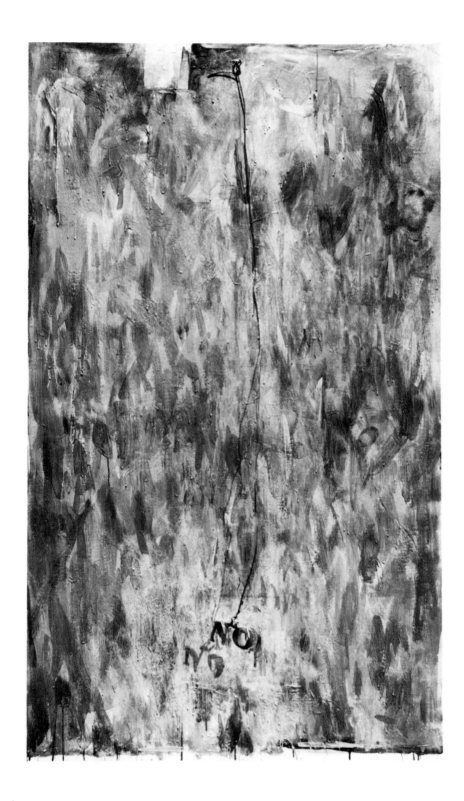

JASPER JOHNS b.1930

*51 *NO.* 1961
 Encaustic, collage and sculpmetal on canvas with objects,
 68 x 41¼"
 Lent by the artist

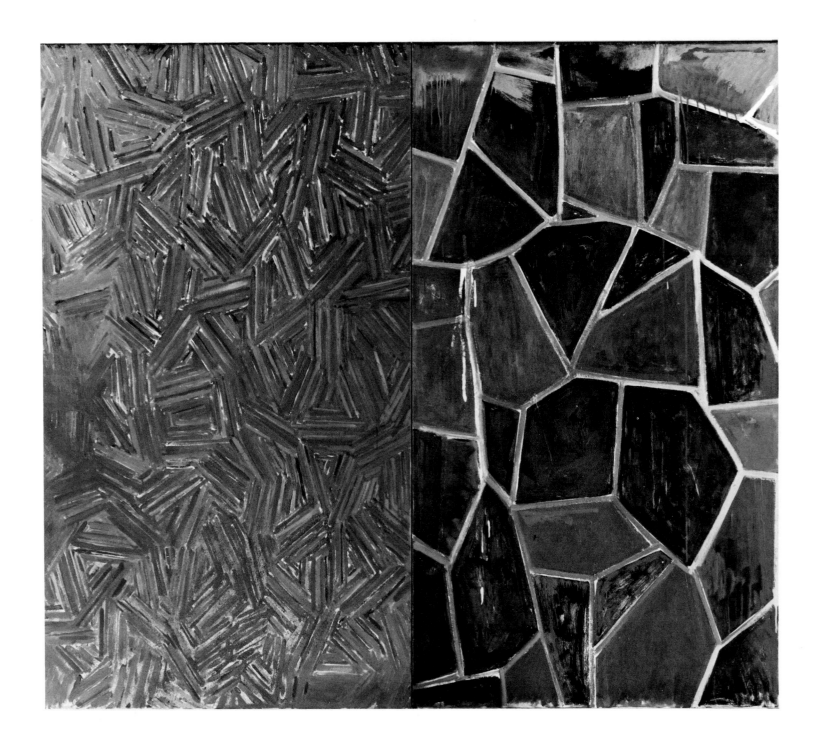

JASPER JOHNS

52 *End Paper.* 1976
 Oil on canvas, 60 x 69½″
 Lent by the artist and courtesy Leo Castelli Gallery, New York

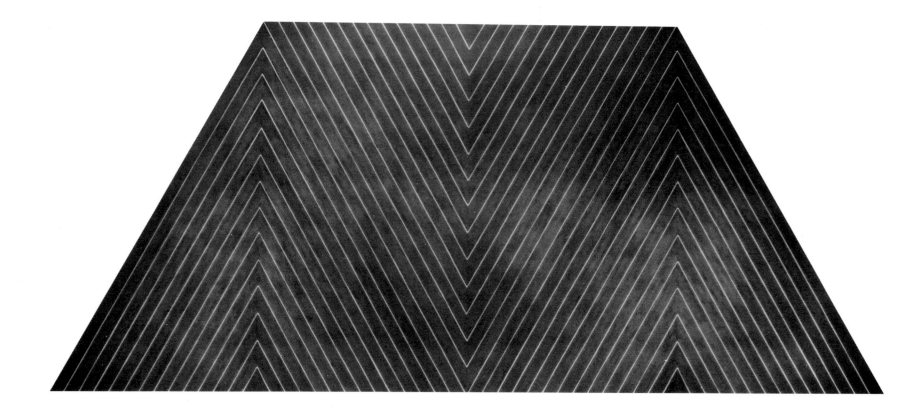

FRANK STELLA b.1936

53 *Valparaiso Red.* 1963
Metallic paint on canvas, 90 x 178″ (outside edge x bottom)
Lent by Blum/Helman Gallery, New York

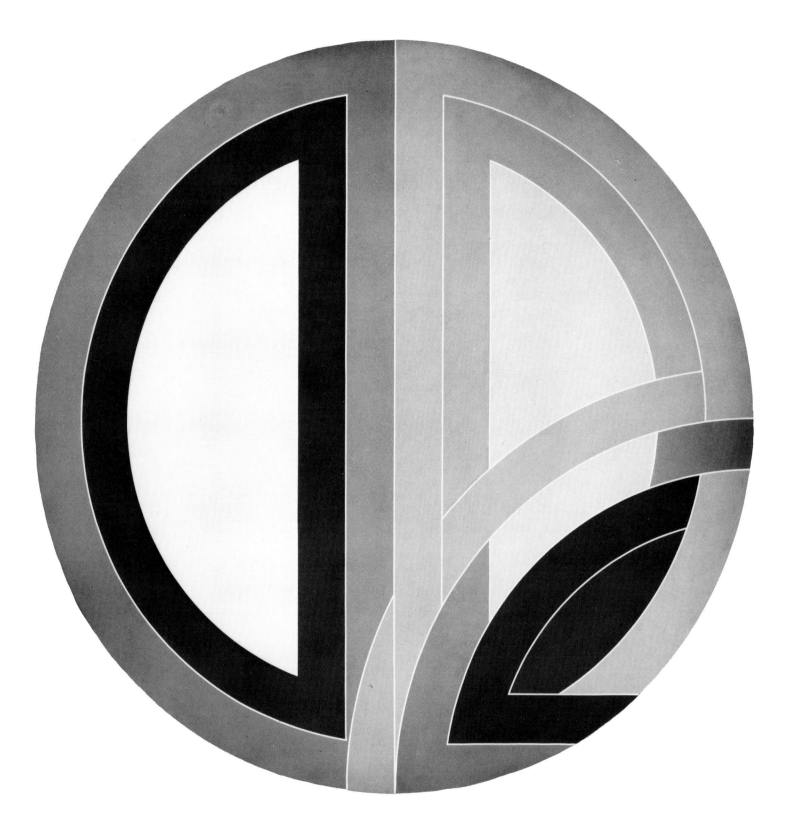

FRANK STELLA

*54 *Sinjerli Variation I.* 1968
Acrylic on canvas, 120″ diameter
On extended loan to The Solomon R. Guggenheim Museum,
New York, from Harry N. Abrams Family Collection, New York

Biographies

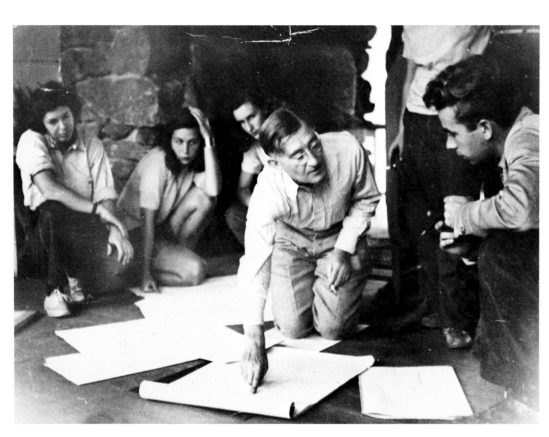

Albers at Black Mountain College

Biographies

JOSEF ALBERS 1888-1976

Born in Bottrop, Germany. Studies to become teacher, 1902-08. Studies art in Berlin, Essen, Munich, 1913-20, while teaching school. 1920-23, student at *Bauhaus*, Weimar, concentrating on glass painting. 1922, while a student, appointed *Bauhausgeselle* (journeyman), in which capacity he organizes *Bauhaus'* reopened glass workshop, designing and executing stained-glass windows, and conducts *Vorkurs* (preliminary design course). Moves with *Bauhaus* to Dessau and is promoted to *Bauhausmeister*, 1925: continues to teach *Vorkurs*, in which functional and aesthetic properties of materials are explored. Works in many disciplines such as furniture design and typography.

1933, *Bauhaus* closed by Nazis, Albers emigrates to United States. Heads art department of newly established experimental Black Mountain College, Black Mountain, North Carolina, 1933-49. 1939, becomes United States citizen. Chairman, Department of Design, Yale University, New Haven, 1950-58; remains at Yale as visiting professor until 1960. Teaches and lectures at numerous other institutions in United States during these years.

In *Bauhaus* tradition, involves self throughout career with wide range of artistic activities: produces prints, fine books, graphic portfolios; writes poetry, articles, books. Extensive exhibitions in United States and abroad since first New York one-man show, J. B. Neumann's New Art Circle, 1936. Numerous retrospectives, including The Metropolitan Museum of Art, New York, 1971.

Stylistic development characterized by ever more simplified forms, continuing concern with dynamic interrelationship of light and color. 1930s, begins freely brushed abstractions of simple elements like letters and numbers; 1940s, more radical reduction. 1949, starts *Homage to the Square* series, to which he subsequently restricts himself exclusively. In this series, isolation of central motif, precise adjustments of form to frame culminates, psychic effects and interaction of color exhaustively explored. Identical arrangement of squares, but infinitely varied color combinations in these paintings. Several generations of artists influenced by Albers' teaching and painting. Like Hofmann, Albers disseminates first-hand knowledge of European modernism to Americans. His intense color, symmetrical formats, single impact images affect younger artists.

WILLIAM BAZIOTES 1912-1963

Born in Pittsburgh. 1913, settles with family in Reading, Pennsylvania. 1933, to New York; studies painting at National Academy of Design, 1933-36. Participates in WPA Federal Art Project: 1936-38, teaches for art project; 1938-40 works in easel painting division. 1948, co-founder The Subjects of the Artist school. Teaches throughout career at New York schools: 1949-52, Brooklyn Museum Art School and New York University; 1950-52, Peoples Art Center, The Museum of Modern Art; 1952-62, Hunter College.

Painting of 1938-40 influenced by Picasso, Miró, Klee. 1940, meets Matta, who introduces him to liberating concept of Surrealist automatism: work thereafter becomes freer, more organic and abstract. Association with Surrealist group includes participation in Breton's *First Papers of Surrealism* exhibition, New York, 1942. First one-man exhibition, Peggy Guggenheim's Art of This Century, New York, 1944. Mid-1940s, mature style begins to emerge: isolated, simplified, enlarged motifs replace compartmentalized images of earlier work. Underwater, floral and faunal imagery,

mysterious, mythical content mark his painting even after 1950 when style becomes more refined. In late works of muted color, forms seem to float in liquid space.

Shows regularly with Kootz in New York, 1946-58. Major posthumous retrospective, The Solomon R. Guggenheim Museum, New York, 1965.

STUART DAVIS 1894-1964

Born in Philadelphia. To East Orange, New Jersey, 1901. Through parents, both of whom are involved with art, early contact with artists including Sloan, Luks, Glackens, Shinn. Leaves high school after attending from 1908-10 to study under Henri in New York, 1910-13. 1910, shows in *Independents* exhibition, New York. Exhibits watercolors at Armory Show, New York, 1913: intensely impressed by European art he sees there, especially van Gogh, Gauguin, Matisse. Influence of these artists and contact with Demuth, summer 1913, Provincetown, Massachusetts, important to his development. Settles in New York, fall 1913: begins drawings and covers for Sloan's *The Masses*, cartoons for *Harper's Weekly*. Spends most summers in Gloucester, Massachusetts, 1915-34.

First one-man exhibition, Sheridan Square Gallery, New York, 1917: work by this time semi-abstract. Mature style evolved by late 1920s. Shows regularly at Edith Halpert's Downtown Gallery, New York, 1927-62. 1928-29, in Paris. 1931-32, teaches at Art Students League, New York. Joins WPA Federal Art Project, 1933, executes several murals. Active in Artists' Union: edits their

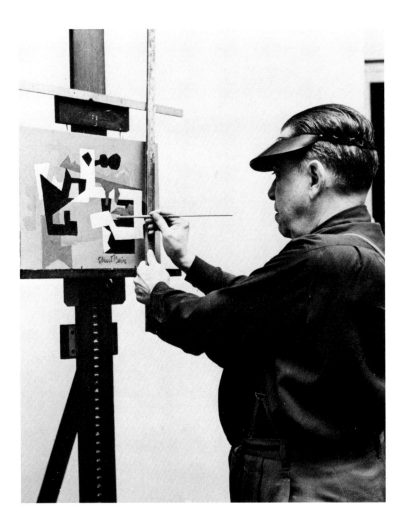

Stuart Davis working on study for
Colonial Cubism, 1954

magazine, *Art Front*, 1935-36. Member Artists' Congress, serves as its National Secretary, 1936, National Chairman, 1938. Teaches at New School for Social Research, New York, 1940-50. Honored by a number of one-man museum shows, including memorial exhibition, National Collection of Fine Arts, Washington, D.C., 1965.

Davis recognized as major force in development of independent modern American art. Distinctly American feeling informs abstract work of intense color, sharp-edged forms, vibrant rhythms. Integration of words often drawn from advertisements into compositions and use of images of common objects ally Davis with Pop movement.

RICHARD DIEBENKORN b. 1922

Born in Portland, Oregon. Studies prolonged by military service: attends Stanford University, Palo Alto; University of California at Berkeley, intermittently from 1940; receives BA from Stanford, 1949. 1946, enrolls at California School of Fine Arts, San Francisco (now San Francisco Art Institute); becomes friendly with Park here. 1947, joins this school's faculty, remains there as teacher until 1950. Colleagues here are Still, Park, Bischoff, Hassel Smith, Corbett, and during two summers, Rothko. Much affected by pervasive Abstract Expressionist style and presence of Rothko and Still. Studies and is influenced by de Kooning's drawing. First one-man show of Abstract Expressionist work, California Palace of the Legion of Honor, San Francisco, 1948.

1950, enrolls at University of New Mexico, Albuquerque: 1951, receives MA. Remains in Albuquerque until 1952 because of light and desert which encourage his predisposition towards landscape painting. Teaches at University of Illinois, Urbana, 1952-53; spends summer in New York; returns to Berkeley, October 1953. Conveys sense of flat horizontal desert landscape in abstract paintings. 1955, begins to experiment with figuration. 1955-57, teaches at California College of Arts and Crafts, Oakland, and during summers at University of Southern California, Los Angeles, and University of Colorado, Boulder. First one-man exhibition on east coast, Poindexter Gallery, New York, 1956, comprised of earlier Berkeley abstractions. 1959-63, teaches at San Francisco Art Institute, 1963-64, artist in residence at Stanford University. Major retrospective at Gallery of Modern Art, Washington, D.C., 1964, subsequently travels in United States.

Settles in Santa Monica, 1966. Teaches at UCLA, 1966-73. Southern light and landscape influence him: he begins to paint abstractly again, starts *Ocean Park* series, 1967. *Ocean Park* paintings first shown, Poindexter Gallery, New York, 1968; more recent paintings in series exhibited San Francisco Museum of Art, 1973; Marlborough Gallery, New York, 1975. Retrospective to be presented Albright-Knox Art Gallery, Buffalo, and circulate thereafter, 1976-77.

SAM FRANCIS b. 1923

Born in San Mateo, California. Studies at University of California, Berkeley, 1941-43. Serves in Army Air Corps, 1943-45. 1944, due to injury sustained during service, to Fitzsimmons Army Hospital, Denver, where he begins to paint in figurative style. 1945-47, at Fort Miley Veteran's Hospital, San Francisco: meets Park who introduces him to work of Picasso, Miró, Klee. First completely abstract painting, 1947. Abstractions reveal affinities with Abstract Expressionism. Returns to University of California, Berkeley, to major in art; receives BA, 1949; MA, 1950.

1950, settles in Paris, studies briefly there at *Académie Fernand Léger*. Banishes color from work, begins muted, smoky gray and white paintings in response to Paris light. Monochromatic blue, red, green series follows; black becomes important element in early 1950s. First one-man show, Galerie du Dragon, Paris, 1952. 1956, first one-man show in New York, Martha Jackson Gallery, which represents him until 1970. From mid-1950s, increasingly extensive exhibitions in both Europe and United States, later Japan. First museum exhibitions, Seattle Art Museum, 1959; Kunsthalle Bern, 1960. 1957-60, travels widely with extended stays in New York, California and Mexico, Japan.

1962, settles in Santa Monica, where he still lives; also maintains studios in Venice Beach, California, Paris, Bern, Tokyo; travels widely. First lithographs, 1960. 1963 at Tamarind Lithographic Workshop, Los Angeles; thereafter increasingly concerned with lithography. Paints almost exclusively in blue for several years from 1960. Free-flowing color areas, cell-like shapes floating in space characterize work of early 1960s. More formal discipline replaces gestural emphasis, c. 1965. From 1966, "white ring" or "sail" paintings, in which color is restricted to narrow strokes at edges of white canvas. 1970, begins to fill white void with color splashes, "matrix" paintings with complex lattices of color bands emerge. Involvement with Jungian thought reflected in concern with expression of subconscious in paintings of 1970s, for example in "mandala" series. Major museum retrospectives include The Museum of Fine Arts, Houston, 1976; Albright-Knox Art Gallery, Buffalo, 1972, which travels to other United States cities into 1973. Represented in New York by André Emmerich Gallery since 1971.

HELEN FRANKENTHALER b. 1928

Born in New York. Studies with Tamayo at Dalton School, New York. Attends Bennington College, Bennington, Vermont 1946-49, studies with Feeley, among others; receives BA. 1947, spends non-resident term in New York, works for magazine *Art Outlook*, studies at Art Students League. 1949, upon return to New York, graduate studies at Columbia with Schapiro. Summer 1950, studies briefly with Hofmann in Provincetown; visits Black Mountain College, Black Mountain, North Carolina. Around this time meets many first-generation Abstract Expressionists. Deeply affected by Pollock show at Parsons, New York, 1951. Influenced also by early Kandinsky, Gorky of mid-1940s. 1951, first one-woman exhibition, Tibor de Nagy Gallery, New York, where she shows through 1958. 1952, produces influential *Mountains and Sea* in original stain technique in which paint soaks into unprimed canvas. Shortly thereafter characteristic style of lyrical color abstractions emerges. Predominantly large scale, mature canvases often recall organic phenomena. Married to Motherwell, 1958-71. Fall 1959, receives first prize, *I Biennale de Paris*. Since 1959, shows regularly in New York at André Emmerich Gallery. Summers in Provincetown, Massachusetts, 1961-69. Teaches at School of Education, New York University, 1959; Hunter College, New York, 1962; The School of Visual Arts, New York, 1967; School of Art and Architecture, Yale University, 1967; Princeton University, New Jersey, 1971. Honored by museum exhibitions including The Jewish Museum, New York, 1960; Whitney Museum of American Art, New York, which travels to London, 1969; Corcoran Gallery of Art, Washington, D.C., 1975, circulating in United States. First experiments with ceramic tile at Bennington Pottery, Vermont, 1964; recent tiles shown at The Solomon R. Guggenheim Museum, New York, 1975. First sculpture, 1972. Lives in New York.

ARSHILE GORKY 1905-1948

Born Vosdanig Manoog Adoian in Khorkhom Vari, Haiyotz Dzor, Turkish Armenia. Studies art at Polytechnic Institute, Tiflis, U.S.S.R., 1916-18. To United States, 1920: lives in Watertown, Massachussets, then Providence, where he studies at Rhode Island School of Design and Providence Technical High School. By 1923, to Boston, studies there at New School of Design. 1925, to New York, enrolls at Grand Central School of Art, soon joins faculty and teaches there until 1931. Changes name to Arshile Gorky during this period. 1929-34, friendship with Stuart Davis; c. 1933, friendship with de Kooning: the two share a studio, late 1930s. Becomes American citizen, 1939.

First one-man exhibition, Mellon Galleries, Philadelphia, 1934. 1935, joins WPA Federal Art Project: executes murals including series for Newark Airport. First one-man exhibition in New York, Boyer Galleries, 1938.

Early work derivative first of Cézanne, then Cubist Picasso, Miró. In 1940s profoundly affected by European Surrealists-in-exile: Masson, Tanguy and especially Matta are liberating influences.

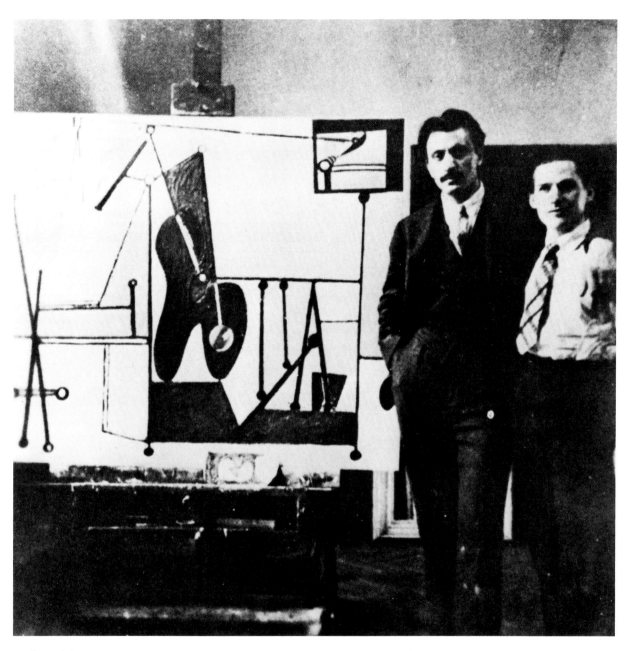

Gorky and de Kooning, c. 1935

Personal style emerges by 1943. Stable and orderly compositions of imitative phase replaced by canvases in flux, fields of energy with scattered, spontaneous, insubstantial organic forms.

From 1942-47, draws and paints in the country, either in Sherman, Connecticut, or Hamilton, Virginia, for part of each year. 1947, settles in Sherman. Shows annually at Julien Levy Gallery, New York, 1945-48. Dies by suicide in Sherman, Connecticut. Posthumous recognition includes regular shows at Kootz and Janis galleries, New York, numerous museum exhibitions including important presentation at The Museum of Modern Art, New York, 1962, and most recently, *Arshile Gorky: Drawings to Paintings*, University Art Museum, The University of Texas at Austin, 1975, subsequently circulating in United States.

ADOLPH GOTTLIEB 1903-1974

Born in New York. Leaves high school to study at Art Students League, New York, with Sloan and Henri, 1920. 1921, to Europe, studies at the *Grande Chaumière,* Paris, and other schools; visits Berlin, Munich. 1923, returns to New York, finishes high school and studies at Art Students League, Cooper Union, Educational Art Alliance, Parsons School of Design. Meets and becomes friends with Newman at League. First one-man exhibition, Dudensing Galleries, New York, 1930. 1935, co-founder of *The Ten,* expressionist-oriented group which exhibits together annually until 1940. Works briefly in easel division, WPA Federal Art Project, 1936. 1937-39, lives in desert near Tuscon. Spends summers, 1939-46, in Gloucester, Massachusetts, with Avery, whose work he greatly admires.

From 1940s, regular exhibitions in New York with major galleries including Kootz, Emmerich. 1941, first "pictographs," canvases divided into irregular grids, each compartment of which is filled with archetypal, mythic images. Like Rothko, Baziotes and others, greatly concerned with expression of universal themes. 1951, begins "imaginary landscapes," canvases divided into two areas with floating shape above, static "landscape" form below. 1957, starts *Burst* paintings, in which contrasting forms of previous "landscapes" are simplified into disc hovering above exploding mass.

Summers in Provincetown, Massachusetts, from 1946 until he moves to East Hampton, Long Island, 1960. 1958, teaches at Pratt Institute, Brooklyn, and UCLA. Represented by Marlborough Gallery, New York, since 1964. Joint retrospective organized by The Solomon R. Guggenheim Museum and Whitney Museum of American Art, New York, 1968.

PHILIP GUSTON b. 1913

Born in Montreal. 1919, to Los Angeles, where he later attends Manual Arts High School: Pollock is a schoolmate. Only formal art training, several months at Otis Art Institute, Los Angeles, 1930. 1934, to Mexico to study Orozco and Rivera murals. Works in mural division of WPA Federal Art Project upon return to Los Angeles. 1936-40, in New York, paints murals for Project there. 1941-45, visiting artist at University of Iowa, Iowa City: has first one-man show there, 1944. 1945-47, visiting artist, Washington University, St. Louis. By early 1940s recognized as important figurative artist: during these years paints sad children in urban environments, political themes. 1945, first one-man exhibition in New York, Midtown Galleries. 1947, moves to Woodstock, New York, where he lives now. Winter 1947, paints first abstraction. Travels in Europe, 1948-49, on John Simon Guggenheim Fellowship granted in 1947, *Prix de Rome,* American Academy of Arts and Letters grant. 1950, visiting artist, University of Minnesota, Minneapolis; subsequently returns to New York and Woodstock.

By 1951, arrives at mature abstract style characterized by centrally placed patchwork of overlapping, delicate brushstrokes, luminous color, impressionist feeling. Introduces black into more densely painted surfaces of canvases of mid-1950s. Overall sobriety marks work of 1960s. Has recently returned to figuration: cartoon-like, satirical images often parodying Ku Klux Klan recall some themes of 1940s.

Later teaching career includes New York University, 1951-58; Pratt Institute, Brooklyn, 1953-58; Guest Critic Yale Summer School, Norfolk, Connecticut, intermittently from 1961; Artist in Residence, American Academy, Rome, 1971. Receives Distinguished Teaching Award, The College Art Association of America, 1975. Extensive exhibitions include retrospectives at São Paulo Bienal, 1959; Venice Biennale, 1960; The Solomon R. Guggenheim Museum, New York, 1962, which subsequently travels to Europe and Los Angeles; Rose Art Museum, Brandeis University, Waltham, Massachusetts, 1966; The Metropolitan Museum of Art, New York, 1973 (drawings). Most recent one-man exhibition in New York, David McKee Gallery, 1974.

Frankenthaler with Hofmann in
his Provincetown studio, 1965

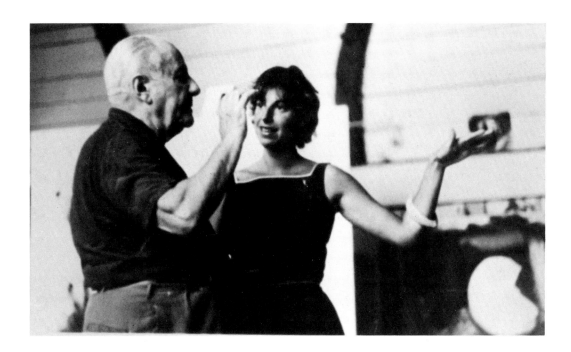

HANS HOFMANN 1880-1966

Born in Weissenburg, Bavaria. 1886, to Munich, where he is educated. From 1898, studies at various art schools in Munich. Support of Berlin collector Phillip Freudenberg allows him to live in Paris, 1904-14: here he attends *Grande Chaumière* when Matisse is there, knows Picasso, Braque, other Cubists.. Friendship with Delaunay stimulates interest in color. First one-man exhibition, Paul Cassirer, Berlin, 1910. Paints Cubist-style figures, still lifes at this time.

Extensive teaching career begins when he opens art school, Munich, 1915. To California to teach, summer 1930, spring 1931. First one-man show in United States, comprised of drawings, California Palace of the Legion of Honor, San Francisco, 1931. Settles permanently in United States, closes Munich school, 1932, due to German political climate. Teaches at numerous American schools, including Art Students League, New York, 1932-33. Opens first school in New York, 1933; succeeded by Hans Hofmann School of Fine Arts, New York, 1934, and summer school, Provincetown, Massachusetts, 1935.

1935, returns to painting after long period of drawing. Work of late 1930s marked by bravura brushwork, bright color, turbulent surfaces which almost overwhelm representational elements. Personal, completely abstract style emerges, 1940s: paintings with uniformly activated all-over surfaces, spontaneous technique. Becomes American citizen, 1941. First one-man exhibition in New York, Peggy Guggenheim's Art of This Century, 1944. Subsequently shows widely, including regular exhibitions at Kootz Gallery, New York, 1946-66. Major retrospectives held at Addison Gallery of American Art, Andover, Massachusetts, 1948; Whitney Museum of American Art, New York, 1957, subsequently circulating in United States; The Museum of Modern Art, New York, 1963; then circulating internationally. 1958, closes both schools to concentrate on painting.

Hofmann fuses wide range of elements in work: structure of Mondrian, Cézanne and Cubism; automatism, fluid color of Kandinsky; saturated hues of Matisse. Most successful synthesis of opposing poles of spontaneous emotion, intellectual control from 1950s. Late 1950s: best known works in which rectangles anchor freely applied paint.

Enormously influential as painter and teacher. Like Albers, transmits direct experience of European art to younger Americans. Analyses of pictorial forces, emphasis on dynamism of three-dimensional space conveyed without compromise of flat canvas plane, role of color and free paint handling of particular importance to creators of freer modes of American abstraction.

ALFRED JENSEN b. 1903

Born in Guatemala City, Guatemala. After mother's death, sent to parents' native Denmark, 1910: studies at Real School, Hirsholn, until 1919. To United States, 1925; studies at Fine Arts Gallery, San Diego, 1925-26. 1926-34, travels extensively in Europe, visits France, Italy, Germany, Spain. Studies with Hofmann in Munich, 1927-28; attends *Académie Scandinave*, Paris. 1929-51, advisor to Saidie A. May on formation of her collection. First one-man exhibition, Heller Gallery, New York, 1952. Teaches at Maryland Institute, Baltimore, summer 1958.

Works in mode related to Abstract Expressionism, producing both abstract and figurative work before emergence of mature style around 1957. Fully developed idiom closer to geometric abstraction than Abstract Expressionism. Utilizes large repertory of geometric shapes executed in thick impasto, intense color. Intricate symbolism of color, shape, number, placement of forms based on complex amalgam of past experience, for example, exposure as child to Central American Indian cultures, and investigations of ancient cultures, including study of I-Ching, Mayan and Egyptian calendars, Pythagorean geometry, early writers on science, religion, art, architecture. Study of Goethe's color theories in *Zur Farbenlehre* influence Jensen's thoughts on color and light.

Has exhibited widely in both United States and Europe. Honored by one-man exhibitions in European museums, including Stedelijk Museum, Amsterdam, 1964, and Kunsthalle, Baden-Baden, 1973. Major exhibition to be presented at Albright-Knox Art Gallery, Buffalo, 1977. Since 1972, has shown at The Pace Gallery, New York. Lives in Glen Ridge, New Jersey.

JASPER JOHNS b. 1930

Born in Augusta, Georgia. Grows up in South Carolina; attends University of South Carolina, Columbia. 1949 to New York, where he briefly studies art before being drafted into army. 1952, returns to New York. 1954-55 first *Target, Flag* paintings; integrates three-dimensional objects into paintings. 1958, these works shown at first one-man exhibition, Leo Castelli Gallery, New York, where he has since shown regularly. Begins sculpture in mid-1950s, using flashlights, lightbulbs, beer cans as subject matter. Mid-1950s, friendship with Rauschenberg, Cage starts: all live in same building. Like Rauschenberg, influenced by Duchamp's use of commonplace objects in art. Makes *Number, Alphabet, Map* paintings. Series of gray canvases in which this color is exhaustively explored. Employs wax encaustic which emphasizes palpable surfaces, nuanced brushwork. With Rauschenberg forms transitional link between Abstract Expressionists and Pop artists: they often articulate in Abstract Expressionist-related style the blatant American imagery and everyday objects which are Pop Art's subjects. Johns' work also affects many younger American abstract painters, sculptors and conceptual artists.

Intensive and innovative work in printmaking since first lithographs in 1960. From 1963, Director of Foundation for Contemporary Performance Arts. Since 1966, artistic advisor to Merce Cunningham Dance Company. Collaborates with Cunningham and Cage on ballet for Paris Opera, 1973. Museum exhibitions include Columbia Museum of Art, South Carolina, 1960; The Jewish Museum, New York, 1964, and subsequently at Whitechapel Gallery, London, 1964; Pasadena Art Museum, 1965. Important drawing show, organized by Arts Council of Great Britain, circulates in England, 1974-75. Forthcoming exhibition at Whitney Museum of American Art, New York. Lives in upstate New York and St. Martin, West Indies.

ELLSWORTH KELLY b. 1923

Born in Newburgh, New York. Attends Pratt Institute, Brooklyn, 1941-42. Military service in France and England, 1943-45. 1946-48, studies drawing and painting at School of the Museum of Fine Arts, Boston, while living and teaching at Norfolk House Center, Roxbury, Massachusetts.

1948, to France, settles in Paris. Attends *Ecole des Beaux-Arts*, 1948. Studies Romanesque painting and architecture. Is exposed for first time to Surrealism and Neo-Plasticism. Practices automatic drawing, also makes first quasi-geometric abstraction, 1949. 1950, meets Arp: Kelly's innate predilection for smooth biomorphic forms encouraged; he begins chance collages, 1950. Teaches at American School, Paris, 1950-51. First one-man exhibition, Galerie Arnaud, Paris, 1951. Paints in south of France, 1951-52. 1954, returns to New York. Lives for a while on Coenties Slip, neighbors there are Youngerman, Martin, Indiana. First one-man show in New York, Betty Parsons Gallery, 1956. First of numerous sculptures executed for Transportation Building, Penn Center, Philadelphia, 1956. Mural commission for UNESCO, Paris, 1969.

Since c. 1950, alternates among regular, irregular, geometric and curved formats. Begins panel paintings in early 1950s. Most often uses brilliant color and black and white but recently has experimented with subtle variations of gray. Identification of color and hard-edged forms charactertizes mature work.

Extensive exhibitions in United States and abroad include major presentations at Albright-Knox Art Gallery, Buffalo, 1972; The Museum of Modern Art, New York, 1973; regular shows at Parsons, then Janis, currently Leo Castelli Gallery, New York. Lives in Chatham, New York.

Rauschenberg and Johns at Rivers show, Tibor de Nagy Gallery, New York, December 1958

Photo © Fred W. McDarrah

FRANZ KLINE 1910-1962

Born in Wilkes-Barre, Pennsylvania. Grows up in Pennsylvania coal mining country. 1931, to Boston. Studies painting, Boston University, 1931-35; Heatherley's Art School, London, 1937-38. By late 1938, settles in New York, where he lives until his death.

1940s, friendly with emerging Abstract Expressionists but paints realistic portraits and urban landscapes. Mature abstract black and white style begins to appear, c. 1949. Abstractions first shown in first one-man exhibition, Egan Gallery, New York, 1950. Teaches at Black Mountain College, Black Mountain, North Carolina, summer 1952; Pratt Institute, Brooklyn, 1953-54; Philadelphia Museum School of Art, 1954. Soon after first one-man show begins to exhibit extensively in Europe and United States, including shows at Egan, then Janis, and Marlborough galleries, New York. His estate now represented in New York by David McKee Gallery. Major museum exhibitions include show organized by The Museum of Modern Art, New York, circulating in Europe, 1963-64; retrospective, Whitney Museum of American Art, New York, 1968, circulating in United States into 1969.

Although often carefully composed from sketches, dramatic black and white gestural canvases seem spontaneous: use of cheap, fast drying black house enamel enhances sense of immediacy, direct impact. As paintings become denser in mid-1950s, Kline begins to introduce color. Experiments with color continue until his death.

Rothko and de Kooning, standing, Kline, Janis, Guston, seated, in front of *Easter Monday*, at de Kooning show, Janis Gallery, New York, April 1956

WILLEM DE KOONING b. 1904

Born in Rotterdam. 1916-25, studies intermittently at Rotterdam Academy of Fine Arts and Techniques; apprenticed to commercial art and decorating firm, art director and designer. To United States, 1926. Lives in Hoboken, New Jersey, works at various jobs including house painting. 1927, to New York, works as commercial artist. Meets Graham, Davis, Gorky; in late 1930s shares studio with Gorky. 1935, begins to paint full-time; participates in mural and easel divisions, WPA Federal Art Project, 1935-36.

Late 1930s paints figures in interiors, still lifes revealing Surrealist influence. Figurative and abstract styles sometimes evolve concurrently, sometimes in successive stages: each mode complex, ambiguous. 1938, begins first *Women* series; female figure becomes a major preoccupation and he stops painting males entirely by 1940. Black and white abstractions, 1945-47: these shown in first one-man exhibition, Egan Gallery, New York, 1948. These all-over abstractions firmly establish de Kooning's reputation as preeminent avant-garde force. Teaches at Black Mountain College, Black Mountain, North Carolina, summer 1948. 1947, resumes paintings of women: 1950, beginning of important, best-known, *Women* series. Mid-1950s, abstract urban, parkway, pastoral landscapes replace figures. *Women* reappear by 1960 to remain in various forms to present. 1961, becomes United States citizen. 1963, moves to Springs, Long Island, where he still lives; begins woman in landscape series. First sculpture cast, 1969. Begins life-size figurative sculpture, 1970-71. Major retrospective, The Museum of Modern Art, New York, 1968, subsequently travels in United States and Europe. Drawings and sculpture shown at Walker Art Center, Minneapolis, 1974, thereafter in other American cities and Canada.

ROY LICHTENSTEIN b. 1923

Born in New York. Studies with Reginald Marsh at Art Students League, New York, summer 1939; 1940-43, Ohio State University, Columbus; after military service, 1943-46, returns to Ohio State, studies with Hoyt L. Sherman, 1946 receives BFA, 1949 MFA. 1949-51, teaches at Ohio State, 1951-57, lives in Cleveland, painting and supporting self as engineering draftsman. 1949, first one-man show, Ten Thirty Gallery, Cleveland; 1951, first one-man exhibition in New York, Carlebach Gallery. Teaches at State University of New York, Oswego, 1957-60; Douglass College, Rutgers University, New Brunswick, New Jersey, 1960-63. Thereafter paints full-time.

During 1950s, shows at Heller Gallery, New York; progresses from depiction of western subjects to assemblages to a form of Abstract Expressionism. At Douglass becomes friends with Kaprow. 1961, paints comic strip themes, isolated objects of common origin, uses Ben Day dots: imagery similar to Warhol's at this time. 1962, first one-man show at Leo Castelli Gallery, New York, where he still exhibits. Expands repertory of subjects to versions of earlier artists such as Cézanne, Matisse, Mondrian, vulgarizing and standardizing masterpieces with Ben Day dots, primary colors. Parodies Abstract Expressionist brushstrokes. 1966-70, derives much of imagery from 1930s decorative style, especially WPA murals. Subsequently moves further toward abstraction in mirror, entablature paintings. Experiments with plastics, enamels, silkscreens, ceramics, sculpture, Lives in New York, 1963-70; settles in Southampton, Long Island, 1970.

MORRIS LOUIS 1912-1962

Born Morris Louis Bernstein in Baltimore. 1929-33, attends Maryland Institute of Fine and Applied Arts, Baltimore, but leaves before completion of courses. Supports self with odd jobs while he paints. 1935, becomes President of Baltimore Artists' Association. 1936-40, lives in New York; 1937-40, works in easel painting division, WPA Federal Art Project. Knows Siquieros, Gorky, Tworkov in New York. Drops last name at this time. Returns to Baltimore, 1940-52, teaches privately. 1952, to Washington, D.C., where he lives until his death. Here he teaches at Washington Workshop Center of the Arts, becomes friends with fellow instructor, Noland. First one-man show, Workshop Center Art Gallery, 1953.

1953, Noland and Louis spend weekend in New York, visit Frankenthaler's studio and are deeply impressed by her stain painting *Mountains and Sea*: a turning point for both artists. Upon return to Washington they work together, explore stain technique. Louis produces first mature work, *Veil* paintings, 1954, utilizing pouring and staining technique: transparent, overlapping layers of color saturate and soak into raw canvas. Works in this technique, 1954, abandons it until 1958 when he makes *Veils* again. Some paintings of period 1955-57 shown in first one-man exhibition in New York, Martha Jackson Gallery, 1957. Louis later destroys many of these interim works. Image and canvas fuse in *Floral* and *Unfurled* stain painting series of 1960-61, *Stripe* canvases of late 1961-62. Totally abstract, they retain sensation of natural phenomena.

Memorial exhibition, The Solomon R. Guggenheim Museum, New York, 1963; traveling exhibition organized by Museum of Fine Arts, Boston, 1967. Major show, National Collection of Fine Arts, Smithsonian Institution, Washington, D.C., 1976.

AGNES MARTIN b. 1912

Born Maklin, Saskatchewan, Canada. Grows up in Vancouver, British Columbia. To United States, 1932, lives until 1940 in Washington and Oregon. 1935-38, studies at Western Washington State College, Bellingham; receives BS, 1942, MS, 1952, from Teachers College, Columbia University, New York. Attends University of New Mexico, Albuquerque, 1946-47. Late 1930s-1950, lives and teaches public school intermittently in Washington, Delaware, New Mexico. Teaches at University of New Mexico, Albuquerque, 1949; Eastern Washington College, La Grande, 1952-53. Becomes United States citizen 1950.

Lives in New York on Coenties Slip, 1957-67: friends and neighbors here are Kelly, Youngerman, Indiana. First one-woman exhibition, Section Eleven of Betty Parsons Gallery, New York, 1958. Characteristic mature style evolves soon after, replacing earlier figure and landscape watercolors, Surrealistic oils, three-dimensional objects. Fully developed style distinguished by square formats, grids drawn on canvas, subtle variations of hue, monochromatic color. Rational order combined with restrained yet subjective feeling of these works exerts profound influence on younger artists. Shows regularly at Robert Elkon Gallery, New York, 1962-74.

1967, moves to Cuba, New Mexico, where she still lives. Work of period 1957-67, shown at Institute of Contemporary Art, University of Pennsylvania, Philadelphia, then Pasadena Art Museum, 1973. Color brighter, grid structure less precise in recent work. First paintings since 1967, executed in 1974, shown at The Pace Gallery, New York, 1975. More new paintings exhibited at Pace, 1976.

ROBERT MOTHERWELL b. 1915

Born in Aberdeen, Washington. To San Francisco, 1918. Studies as child at Otis Art Institute, San Francisco; attends California School of Fine Arts, San Francisco, 1932; Stanford University, Palo Alto, majoring in philosophy, 1932-36. 1935, first of many visits to Europe, beginning of interest in French literature. Graduate work in philosophy, Harvard University, Cambridge, 1937-38; Université de Grenoble, France, 1938; graduate studies in art history, Columbia University, New York, 1940-41, with Schapiro who encourages him to paint. 1941, studies engraving with Seligmann; decides to devote self to painting. 1940s, association with European artists-in-exile in New York, particularly Surrealists; intense interest in automatism. Drawn to abstract art of Arp, Matisse, Miró, Mondrian, Picasso. Collage becomes a major interest, 1943. First one-man exhibition Peggy Guggenheim's Art of This Century, New York, 1944. Active as editor, primarily of *The Documents of Modern Art* and its continuation *The Documents of 20th Century Art,* series of publications devoted for the most part to writings by artists. Also a prolific writer.

L. to r.: Delphine Seyrig, Indiana, Duncan Youngerman, Kelly, Youngerman, Martin, Coenties Slip, New York, 1958

Extensive teaching career includes Black Mountain College, Black Mountain, North Carolina, summers 1945, 1951; founding member The Subjects of the Artist school, New York, 1948; Hunter College, New York, 1951-58, 1971-72. 1948, begins abstract series later known as *Elegy to the Spanish Republic*, notable for balance of carefully organized structure with spontaneous, dramatic black and white forms. Married to Frankenthaler, 1958-71. Since 1956, summers in Provincetown, Massachusetts; since 1971, resides in Greenwich, Connecticut, after living many years in New York.

Among numerous important exhibitions, major retrospective mounted by The Museum of Modern Art, New York, 1965, travels in Europe. 1967, begins *Open* series of large, simplified, brightly colored forms related to Matisse and color-field abstraction.

BARNETT NEWMAN 1905-1970 Born in New York. Attends City College, New York, 1923-27; from 1922 studies at Art Students League, New York, with Sloan, von Schlegel, Duncan Smith. Meets Gottlieb at League; they become friends. During 1930s, supports self as substitute high school teacher while painting. Dissatisfied with development, retains ties with art world but gives up painting, 1939-44. Graduate work in natural science, Cornell University, Ithaca, New York, summer 1941.

Work of c. 1945, informed by automatic drawing, reveals ties to early Kandinsky, Gorky, and in abstract Surrealist imagery and mythological titles to Baziotes, Gottlieb, Rothko. 1946, first use of vertical line as important compositional element. Associated with magazine *The Tiger's Eye*, 1947. Member of The Subjects of the Artist school, New York, 1948. 1948, arrives at characteristic mature style: all allusions to nature, background or foreground abandoned, solid color is interrupted by vertical stripe or "zip" of another color. Enlarges canvases to heroic size. Like Rothko and Still, experiments with vast expanses of pure color to engulf viewer. Unified color fields replace traditional compositional relationships of color, form, space. Deep commitment to expression of spiritual themes. First sculpture, 1950. First one-man exhibition, Betty Parsons Gallery, New York, 1950. Many artists unenthusiastic about next show at Parsons, 1951, and does not exhibit again in New York until 1959, at French and Co.: work then finds young audience drawn to minimal means.

Leader of Artists Workshop, University of Saskatchewan, Saskatoon, Canada, 1959; conducts graduate seminars, University of Pennsylvania, Philadelphia, 1962-63. Retrospective, The Museum of Modern Art, New York, 1971, circulates in Europe 1972.

Newman, Pollock and Tony Smith
at Newman show, Betty Parsons
Gallery, New York, 1950

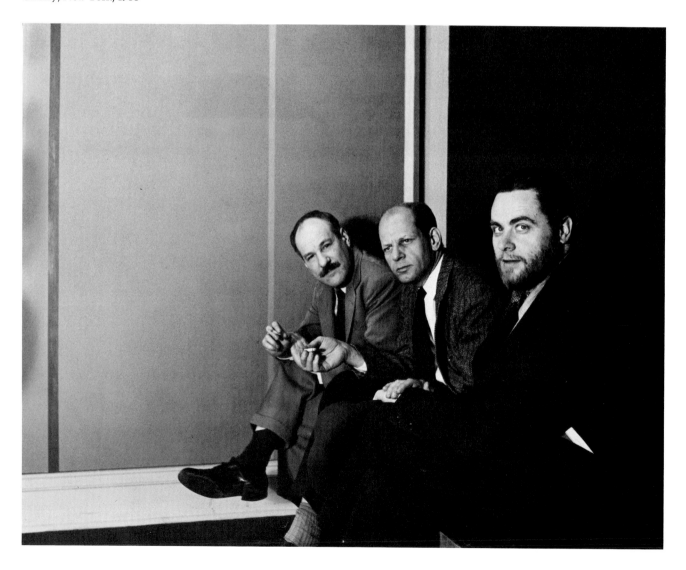

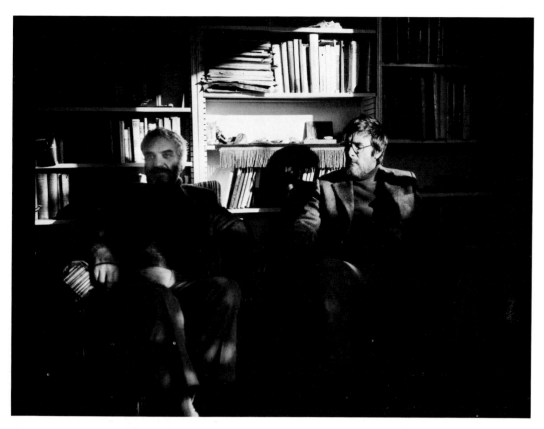

Caro and Noland at David Smith's
house, Bolton Landing, New York,
1971

KENNETH NOLAND b. 1924 Born in Asheville, North Carolina. Studies at Black Mountain College, Black Mountain, North Carolina, 1946-48, primarily with Bolotowsky while Albers is on leave. 1948, to Paris, studies with Zadkine. 1949, first one-man exhibition, Galerie Creuze, Paris. Settles in Washington, D.C., 1949. Teaches in Washington, D.C., at Institute of Contemporary Arts, 1949-51; Catholic University from 1951-c. 1960; Workshop Center for the Arts, from 1952. Early 1950s, friendship with Louis, Greenberg, David Smith. 1953, with Louis and others, visits Frankenthaler's New York studio: they are deeply impressed by her stain painting *Mountains and Sea.* Louis and Noland thereafter together explore stain technique. First one-man show in New York, Tibor de Nagy Gallery, 1957. 1958, first concentric circle paintings; work becomes increasingly geometric. Moves to New York, 1961. First of many one-man exhibitions at André Emmerich Gallery, New York, 1961. Experiments with numerous motifs and formats including: from 1962, ovals, chevrons; 1964, asymmetrical chevrons, diamond shaped canvases; 1965-66, horizontal stripes; 1971-72, "plaid" paintings; 1975, irregularly shaped canvases. Fusion of color, abstract image and canvas shape characterize and clarify various aspects of stylistic evolution. 1964, moves to South Shaftsbury, Vermont, where he still lives. First sculpture, 1966. Major one-man exhibition, The Jewish Museum, New York, 1965; retrospective to be presented at The Solomon R. Guggenheim Museum, New York, 1977.

JULES OLITSKI b. 1922

Born in Snovsk, Russia. To United States, 1923. Grows up in Brooklyn. Studies in New York include drawing classes at Pratt Institute, Brooklyn, 1939; drawing and portraiture at National Academy of Design, 1940-42; sculpture at Beaux-Arts Institute, 1942. 1942, becomes United States citizen; takes stepfather's name, Olitsky. Serves in United States Army, 1942-45. Lives in Brooklyn, Asheville, North Carolina, Mexico, New York, 1945-48. 1949-51 to Paris under G.I. Bill, studies there briefly with Zadkine. 1951, first one-man exhibition, Galerie Huit, Paris; changes spelling of name.

1951, returns to New York. Attends New York University, receives BS in art education, 1952; MA, 1955. Monochromatic canvases with empty centers, painterly incident pushed to margins, replace bright colors and imagery of Paris works. Teaching career includes State University College, New Paltz, New York, 1954-55; C. W. Post College, Brookville, Long Island, 1956-63. First one-man show in United States, Zodiac Gallery of Iolas Gallery, New York, 1958. Work of period thickly impastoed, highly textured. 1960, begins to pour and stain dye into large canvases: prismatic color, biomorphic shapes mark paintings. 1961-65, begins experiments with various acrylics and methods of application on unprimed canvas. Boundaries disappear, color floats downward from canvas top. Teaches at Bennington College, Bennington, Vermont, 1963-67. 1964, first large scale spray painting made with spray gun and compressor. Continuing experiments with paints and techniques produce wide range of effects. 1967, first one-man museum show, Corcoran Gallery of Art, Washington, D.C., travels to Pasadena Art Museum, San Francisco Museum of Art. 1968, first major attempt at sculpture. First show of sculpture is also first one-man exhibition of a living American at The Metropolitan Museum of Art, New York, 1969. Major museum presentation, Museum of Fine Arts, Boston, 1973, travels to Albright-Knox Art Gallery, Buffalo, Whitney Museum of American Art, New York. Represented in New York by Knoedler Contemporary Art since 1973. Lives in New York.

JACKSON POLLOCK 1912-1956

Born in Cody, Wyoming. Grows up in Arizona and California. 1928-30, sporadically attends Manual Arts High School, Los Angeles, where he studies painting and is classmate of Guston. Fall 1930, to New York, studies at Art Students League, with Thomas Hart Benton, one semester with Sloan. Remains at League until 1933. Knows Mexican muralists Rivera, Siqueiros in New York during 1930s, admires their work. After several trips to West, settles permanently in New York, 1935, rarely leaving the area thereafter. 1935-43, participates in easel painting division, WPA Federal Art Project.

In 1940s, knows Surrealists-in-exile in New York, as well as many younger American artists. Commited to Jungian analysis, is convinced of significance of unconscious in art. 1943, briefly works at Museum of Non-Objective Painting (now The Solomon R. Guggenheim Museum). First one-man exhibition, Peggy Guggenheim's Art of This Century, New York, 1943. Thereafter recognized as major young talent, included in numerous shows. 1943-47, contract from Peggy Guggenheim allows him to paint full-time. Work of 1943-47, reflects obsession with primitivism, Jungian subjects. Though totemic ritualistic images not always clearly recognizable, painting is not yet abstract. Marries Lee Krasner, moves to Springs, Long Island, 1945. 1947, Peggy Guggenheim moves to Venice, contract taken over by Parsons; first all-over completely abstract drip paintings. Radical new technique in which paint is poured, dripped and thrown on canvas placed on floor allows Pollock unprecedented freedom, directness, spontaneity. Emotional content formerly embodied in tortured imagery now expressed in totally abstract form. 1951-52, paints primarily in black and white on unsized canvas: these are the first stain paintings. Reintroduces figuration in some later work while continuing total abstractions.

Dies in automobile accident in Long Island. Memorial exhibition, The Museum of Modern Art, New York, 1956. Major retrospective, The Museum of Modern Art, New York, 1967.

ROBERT RAUSCHENBERG b. 1925

Born in Port Arthur, Texas. Attends Kansas City Art Institute, 1946-47. 1947, studies at *Académie Julian*, Paris, under G.I. Bill. 1948, upon return to United States, enrolls in Black Mountain College, Black Mountain, North Carolina, and studies painting, primarily with Albers, as well as photography, music and modern dance. Studies at Art Students League, New York, with Vytlacil and Kantor, 1949-50. 1951, first one-man show at Betty Parsons Gallery, New York, 1951-52, travels in Italy and North Africa. 1952, executes all white and all black paintings in effort to investigate perception of black and white as colors; begins design work with dancers Cunningham and Paul Taylor. 1953, starts all red paintings as extension of experiments begun in black and white works; in well-known gesture, erases de Kooning drawing to emphasize the traditional and safe stance Abstract Expressionism had assumed. 1955-58, makes first *Combines*, constructions which incorporate actual objects (such as stuffed animals, beds and tires), and cannot be classified as either painting or sculpture. During this time, lives in same building with Johns, Cage, who encourage him. Like Johns, is influenced by Duchamp's concept of ordinary non-aesthetic entity as worthy of aesthetic consideration, as well as by the role of chance in art. With Johns, forms transitional link between Abstract Expressionists and Pop artists, especially in use of commonplace objects which are often Pop Art's subjects. Rauschenberg's innovative use of unusual materials also influences younger artists.

1958. begins exhibiting at Leo Castelli Gallery, New York, where he has since shown regularly. 1961, first use of lithography; he subsequently incorporates silk-screen technique into his canvases. Major one-man exhibition at The Jewish Museum, New York, 1963. 1964, wins first prize, Venice Biennale. 1966, co-founder of organization EAT (Experiments in Art and Technology) which promotes cooperation between artists and engineers. In recent work, such as *Cardbirds*, 1971, *Hoarfrost*, 1974-75, and *Jammer*, 1976, series continues to explore new media and form. Founds Change Inc., non-profit organization to provide financial support for artists. Forthcoming exhibition to be held at National Collection of Fine Arts, Washington, D.C., 1976-77, and will subsequently travel in the United States through 1978. Lives in New York and Captiva, island off Florida.

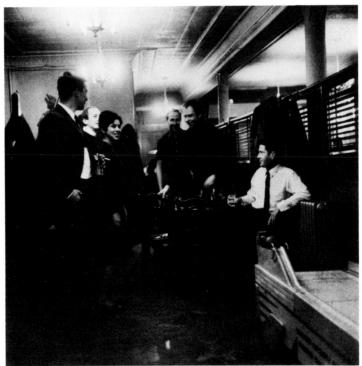

L. to r.: Johns, Bill Giles, Anna Moreska, Rauschenberg, Cunningham and Cage, Dillon's Bar, New York, 1959

Photo © Fred W. McDarrah

AD REINHARDT 1913-1967

Born in Buffalo, New York. Attends Columbia University, New York, 1931-35. 1936, studies at National Academy of Design, New York; independently with Holty and Criss. 1937, joins Artists' Union; 1937-47, member of American Abstract Artists, New York, group commited to geometric abstraction. Reinhardt, the only New York School artist who had always worked in abstract mode, never interested in Surrealism. Participates in easel division of WPA Federal Art Project, 1937-41. 1943, first one-man exhibition, Columbia University, New York. Service in Navy, 1945. Studies at Institute of Fine Arts, New York University, 1946-52. Mid-1940s, works for magazine, *PM*, contributing cartoons satirizing New York art world. 1946-65, regular one-man exhibitions at Betty Parsons Gallery, New York. Teaches extensively, including Brooklyn College, 1947-67; California School of Fine Arts, San Francisco (now San Francisco Art Institute), 1950; Hunter College, New York, 1959-67. Active as writer, primarily of anti-art polemics. Stringent aesthetic theories reflected in reductive color and form of mature work. By 1950, paints brick-like shapes of solid color; by 1953, renounces asymmetry, restricts palette primarily to red, blue, black in monochrome work. From c. 1960, radically reductive, trisected five foot square canvases in shades of black. Minimal emotion and means important to younger American artists. Major retrospective, The Jewish Museum, New York, 1966. Estate represented first by Marlborough Gallery, New York, now by The Pace Gallery, New York.

MARK ROTHKO 1903-1970

Born in Dvinsk, Russia. 1913, to Portland, Oregon. 1921-23, studies liberal arts, Yale University, New Haven. 1925, settles in New York, briefly studies under Weber at Art Students League. First one-man exhibitions at Portland Art Museum, Oregon, and Contemporary Arts Gallery, New York, 1933. 1935, founding member *The Ten*, group of expressionist-oriented artists which includes Gottlieb and exhibits together annually until 1940. 1936-37, participates in WPA Federal Art Project. 1938, becomes United States citizen. By late 1930s, paints realistically, primarily depictions of isolated figures, often in subway settings.

Surrealist artists-in-exile in New York in 1940s influence him in use of automatism, free association. Mid-1940s, produces often stratified abstract landscapes with delicate washes, floating biomorphic forms. Shares commitment to mythic content, predilection for underwater imagery of contemporaries such as Baziotes, Stamos, Newman. Shows mythic Surrealist abstractions in one-man exhibition at Peggy Guggenheim's Art of This Century, New York, 1945. 1947-51, exhibits regularly with Parsons. By 1947, begins to purge literary references, organic allusions from his work: paintings of this year are transitional, with soft patches of color. Winter 1949-50, attains characteristic mature style in which rectangles of dematerialized, light-infused color hover in space. Canvases often extremely large. Continuing concern with expression of significant content in abstract work, particularly emphasizes tragic themes. Co-founder of The Subjects of the Artist school, New York, 1948. Teaches at California School of Fine Arts, San Francisco (now San Francisco Art Institute), summers 1947, 1949; Brooklyn College, 1951-54; University of Colorado, Boulder, 1955; Tulane University, New Orleans, 1956. Late 1950s, introduces black, brown, maroon into palette. Black and gray paintings of late 1960s reveal growing sense of foreboding in work. Extensive exhibitions include major show, The Museum of Modern Art, New York, 1961, which travels to London. Dies by suicide in New York. Dedication of nondenominational chapel with Rothko murals, Institute for Religion and Human Development, Houston, 1971.

FRANK STELLA b. 1936

Born in Malden, Massachusetts. 1950-54, studies at Phillips Academy, Andover, Massachusetts, with Patrick Morgan; 1954-58, Princeton University, New Jersey, with Seitz and Stephen Greene. Early work reflects influence of Abstract Expressionism and Johns. 1958, to New York, where he still lives.

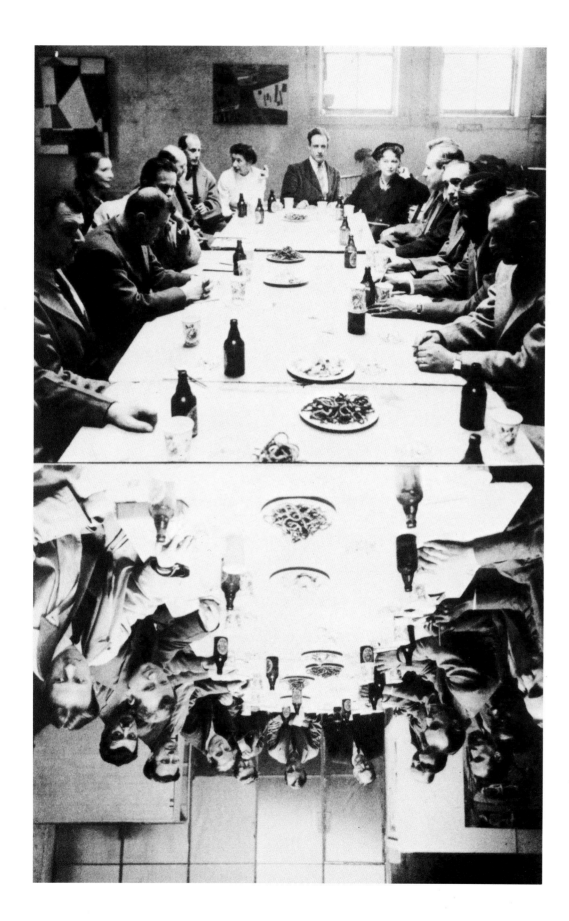

Closed conference, **Studio 35**,
New York, April 1950
Upper photograph: clockwise,
Lipton, Lewis, Jimmy Ernst,
Grippe, Gottlieb, Hofmann, Barr,
Motherwell, Lippold, de Kooning,
Lassaw, Brooks, Reinhardt and
Pousette-Dart
Lower photograph: clockwise,
Brooks, Reinhardt, Pousette-Dart,
Bourgeois, Ferber, Tomlin, Biala,
Goodnough, Sterne, Hare,
Newman, Lipton, Lewis and
Jimmy Ernst

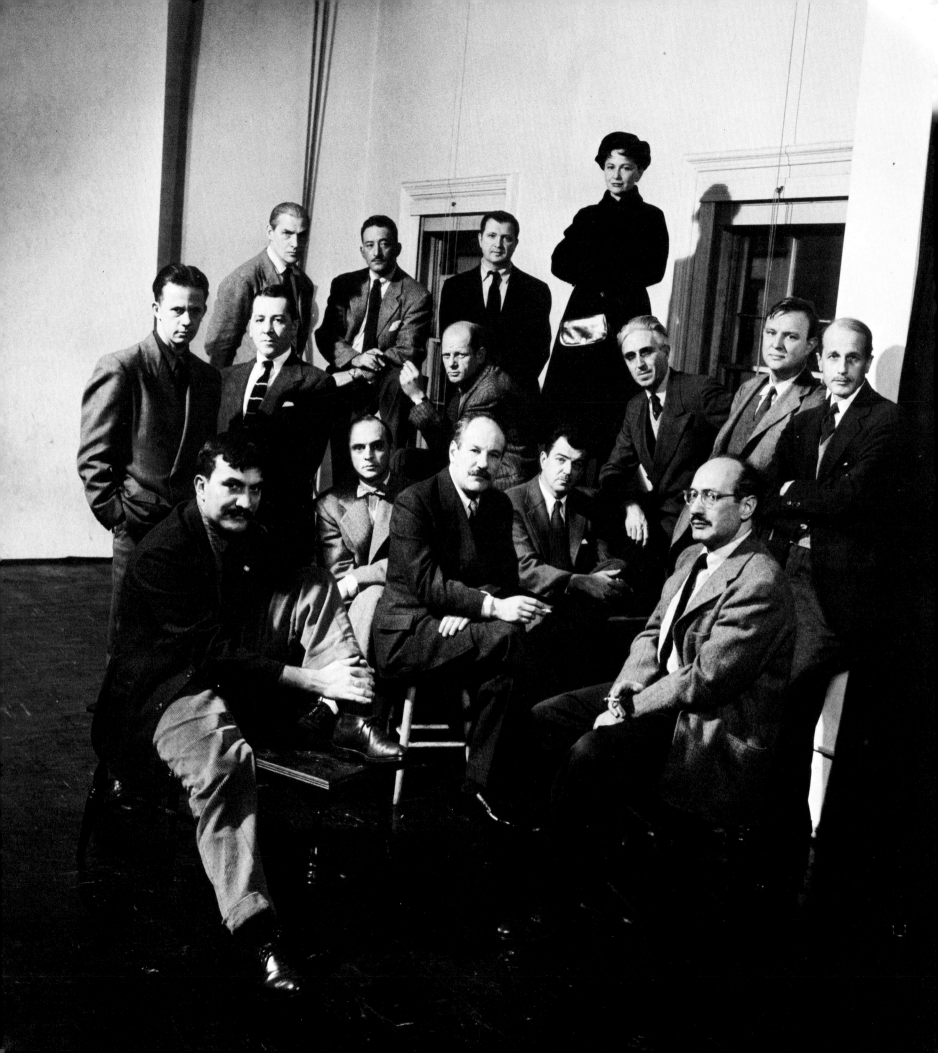

Personal style emerges with *Black* paintings, 1958: symmetrical pattern of stripes echoes canvas edge, creates static, symmetrical, emotionless image. 1960, first one-man exhibition, Leo Castelli Gallery, New York, where he exhibits regularly to present. *Aluminum* paintings, begun 1960, shown in first one-man exhibition, are his first shaped canvases: shape of support echoes pattern of stripes. *Copper* series, 1960-61, more eccentrically shaped, more sculptural. First trip to Europe, fall 1961. Early 1962, returns to New York, introduces varied color into individual compositions, continues to paint monochrome works at same time. Alternates between regularly and eccentrically shaped canvases. 1963, visits Iran; 1965, visits South America. 1965, starts to use wide bands of color in works which evolve into *Irregular Polygon* series: first paintings with large geometric areas of color. 1967, begins large scale, brilliantly colored *Protractor* series, first curvilinear compositions; these he gives names of Near Eastern and Islamic cities with circular plans. 1967, also designs sets and costumes for Cunningham's *Scramble*. Most recent works are object-like relief paintings. Major exhibition, The Museum of Modern Art, New York, 1970.

CLYFFORD STILL b. 1904

Born in Grandin, North Dakota. Grows up in Spokane, Washington and near Bow Island, Alberta. 1925, first visit to New York. Studies at Spokane University: receives BA, 1933. Teaches at Washington State College, Pullman, 1933-41. Fellow at Trask Foundation, Saratoga Springs, New York, summers 1934, 1935. 1935, MA from Washington State College. Works in war industry in Oakland, then San Francisco, 1941-43. First one-man show, San Francisco Museum of Art, 1943. 1943-45, teaches at Richmond Professional Institute (now Virginia Commonwealth University). 1945, moves to New York. One-man show at Peggy Guggenheim's Art of This Century, New York, 1946.

1930s, paints landscapes, single elongated figures striding across canvas. Symbolism of isolated individual, dualities of nature and organic matter, formal structure of these early works prefigure elements of mature abstract style, developed by 1947. Upright figure shapes transformed into vertical areas of flat color. Emphasis on extremely large areas of color which seem to engulf viewer align him with chromatic abstractionists like Newman, Rothko; physicality of surface, rawness, drama of jagged forms align him with gestural painters. 1946-50, lives in San Francisco, teaches at California School of Fine Arts (now San Francisco Art Institute). Still instrumental in establishing importance of this school. 1948, to New York briefly, participates in planning of The Subjects of the Artist school but withdraws before it opens. 1950-61, lives in New York. 1961, settles in Maryland. Major retrospective, 1959, Albright Art Gallery (now Albright-Knox Art Gallery), Buffalo, to which Still gives a large number of his paintings, 1964. Important gift by Still of paintings to San Francisco Museum of Art, 1976. Lives and works in seclusion in New Windsor, Maryland.

MARK TOBEY 1890-1976

Born in Centerville, Wisconsin. Lives in various towns in midwest; settles near Chicago in Hammond, Indiana, 1906. Attends Art Institute of Chicago as youth. 1909, moves to Chicago. Works in steel mill, then as catalogue illustrator. 1911, to New York, works briefly as fashion illustrator for *McCalls* magazine. Until 1917, lives intermittently in Chicago and New York. First exposure to avant-garde art during this period. First one-man show, of charcoal portraits, M. Knoedler & Co., New York, 1917.

By late teens begins to dissolve forms into minute patterns of movement and light but retains figurative elements, which never entirely disappear from work. 1918, conversion to Bahá'í religion, which stresses unity of mankind, may influence rejection of total abstraction. Bahá'í leads him to explore representation of spiritual in art. Oscillates between seeming abstractions, actually depic-

tions of microscopic natural forms, and more conventionally representational works. 1922, to Seattle, teaches at Cornish School of Allied Arts. Learns Chinese calligraphic brush techniques. 1925, to Paris, begins series of lifelong travels. 1926, in Middle East becomes interested in Persian, Arabic script. Returns briefly to Seattle, 1927, then divides time between Chicago and New York. 1931-38, teaches at Dartington Hall, Devonshire, England, with frequent absences for travel, especially in Orient. 1935, white writing style emerges: solid form eliminated in favor of white calligraphy which overlies color. First one-man show of white writing paintings, Willard Gallery, New York, 1944. 1957, evolves Sumi ink or flung-ink paintings.

More acclaimed in Europe than United States, for example, receives Grand Prize, *XXIX Biennale*, Venice, 1958; 1961, is first American to have one-man show at Louvre. One-man exhibition, The Museum of Modern Art, New York, 1962; major retrospective, National Collection of Fine Arts, Washington, D.C., 1974.

BRADLEY WALKER TOMLIN 1899-1953

Born in Syracuse, New York. Studies at John Crouse College of Fine Arts, Syracuse University, 1917-21, receives BFA. 1922, scholarship student at Louis Comfort Tiffany Foundation, Oyster Bay, Long Island; settles in New York. Supports self as commercial artist, painting portraits. First one-man exhibition in towns of Skaneateles, Cazenovia, Madison, New York, 1922. First one-man show in New York, Montross Gallery, 1922. Visits Europe, staying mainly in Paris, but travels also in France, Italy, England, 1923, 1926, 1928. During 1923 visit, studies at *Académie Colarossi* and *Grande Chaumière*, Paris. Work of 1920s recalls Dove, O'Keeffe, Hartley. Around 1929, Frank Rehn Gallery begins to represent him in New York. Teaches at Buckley School, New York, 1932-33; Dalton School, New York, 1933-34; Sarah Lawrence College, Bronxville, New York, 1932-41. Experiments with modified realism, first half 1930s. By late 1930s, work reflects interest in both Surrealism and Synthetic Cubism.

Mature original styles does not emerge until 1945. 1945, meets Gottlieb, through him comes to know other New York School members, most importantly Guston, Pollock, Motherwell. Participates in group's activities, is given one-man shows at Betty Parsons Gallery, New York, 1950, 53. Fully developed style shares all-over surface articulation, large scale, gestural emphasis of Abstract Expressionism but is lyrical and restrained. First total abstractions, 1946; increasingly emphasizes gesture after 1947. Sparse compositions of light strokes on dark grounds with strictly limited palette conceived of as kind of writing, akin to Klee, Tobey, Oriental calligraphy. After 1949, denser compositions are more complex in form, structure, facture, color. *Petal* paintings are among last works: linear structure replaced by free disposition of color spots over canvas. Given two museum retrospectives: Whitney Museum of American Art, New York, 1957; The Emily Lowe Gallery, Hofstra University, Hempstead, 1975, subsequently circulating in United States.

JACK TWORKOV b. 1900

Born in Biala, Poland. 1913, to New York. Studies in New York at Columbia University, 1920-23, Art Students League, 1925-26. 1923, first of many summers in Provincetown, Massachusetts. 1928, becomes United States citizen. 1933, first trip to Europe since emigration to America. Participates in easel division, WPA Federal Art Project, 1935-41. Still lifes, landscapes and portraits of 1920s and 1930s reflect deep interest in Cézanne.

First one-man exhibition, ACA Gallery, New York, 1940. Works in war industry as tool designer, abandons art, 1942-45. 1945, resumes painting, mostly produces still lifes, also starts to experiment with abstraction. 1948-53, studio adjoins de Kooning's: conversations at this time affect Tworkov's thinking. Mature abstract style develops after 1950. Work of 1950s marked by spontaneous, flame-like brushstrokes which define grid. Shows widely, including one-man exhibitions at Egan, Stable, Castelli galleries, New York. Recent work more strictly organized, geometric, less

gestural, with smaller brushstrokes, often in subdued pastel monochrome. Has taught extensively, including Black Mountain College, Black Mountain, North Carolina, summer 1952; Pratt Institute, Brooklyn, 1955-60; School of Art and Architecture, Yale University, New Haven, 1963-69 (as Chairman of Art Department); Columbia University, New York, 1973. Whitney Museum of American Art, New York, mounts exhibition of his work, 1964, which travels in United States into 1965. Now represented in New York by Nancy Hoffman Gallery. Lives in New York and Provincetown, Massachusetts.

ANDY WARHOL b. 1928

Born in Pittsburgh. Studies at Carnegie Institute of Technology (now Carnegie-Mellon University), Pittsburgh, 1945-49, receives BFA. 1949, to New York. Work commercial and illustrational through 1950s. Immediately successful as commercial artist, work first published in *Glamour* magazine, 1949, later *Vogue, Harper's Bazaar,* other publications, and featured in stores. First one-man exhibition, Hugo Gallery, New York, 1952, of illustrations for Capote's writings. Warhol the only Pop artist to start in commercial field. Travels in Europe and Asia, 1956.

Early 1960s, begins to paint comic strip characters, images derived from advertisements. Influence of Johns and Rauschenberg apparent in dripped, unfinished surfaces. New paintings first shown at Ferus Gallery, Los Angeles, 1962. By this time mature style fully developed: this work characterized by repetition, banal and morbid subject matter, expression of boredom, preoccupation with stardom. Active paint handling rejected in favor of anonymous surfaces often achieved through use of silk-screen process, introduced 1962. Form and content drawn from mass media. Until mid-1960s, subjects include Campbell's Soup cans, dollar bills, Brillo boxes, newspaper headlines, movie stars, disasters, flowers, cows. Begins making underground films at New York studio, The Factory, 1963. Movies also marked by obsession with boredom, repetition, neutrality, celebrities. Concentrates on film, 1964 - early 1970s, when he begins to paint again, concentrating on portraits. Recently starts to write. Shows regularly in New York at Castelli Gallery. Important retrospective organized by Pasadena Art Museum, 1970, circulates in United States. Lives in New York.

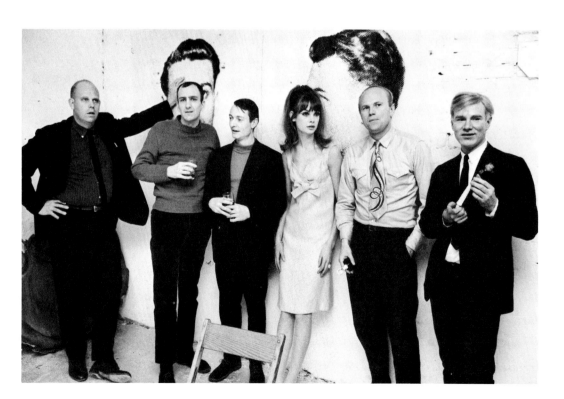

L. to r. Oldenburg, Wesselmann, Lichtenstein, Jean Shrimpton, Rosenquist and Warhol, c. 1965

Photographic Credits

EXHIBITION 76/3

4,000 copies of this catalogue, designed by Malcolm Grear Designers, typeset by Dumar Typesetting, Inc., have been printed by Eastern Press, Inc., in October 1976 for the Trustees of The Solomon R. Guggenheim Foundation.